The Language
of Film

The Language of Film

of Film

Rod Whitaker
University of Texas

Prentice-Hall, Inc., *Englewood Cliffs, New Jersey*

PRENTICE-HALL INTERNATIONAL, INC., *London*
PRENTICE-HALL OF AUSTRALIA, PTY. LTD., *Sydney*
PRENTICE-HALL OF CANADA, LTD., *Toronto*
PRENTICE-HALL OF INDIA PRIVATE LIMITED, *New Delhi*
PRENTICE-HALL OF JAPAN, INC., *Tokyo*

© 1970 by
PRENTICE-HALL, INC.
Englewood Cliffs, N.J.

C–13-522839-5
P–13-522821-2

Library of Congress Catalog Card No.: 72-108739

Current printing (last digit)
10 9 8 7 6 5 4 3 2 1

Printed in the United States of America

Appogiatura

This little book is designed to explore the elements of filmic expression from two points of view: the creative and the perceptual. Each element will be described first in the terms of the film maker, and later in terms of content and effect. Basic to its structure is the assumption that the film experience is composed of pure images and pure sounds, organized through narrative and artistic code structures, and lent meaning by the participation and experience of the audience member. We shall seek to trace the linguistic and mechanical development of the medium; to describe the content implications of image and sound; to suggest the contributions of editing and montage; to examine the cohesive envelopes of plot, theme, narrative organization, and histrionics; to deal with the role of meaning in the modern film; and, finally, to take an overview of the nonlinguistic modes of the avant-garde and the underground.

The material has been organized to be of use to three classes of readers, or to one reader in three moods. The film maker should find most of the information to be obvious, although he may benefit from having it laid out in more or less orderly fashion, and he will find labels for what have been intuitive procedures. The serious filmgoer who enjoys cocktail debates about the merits of films and film makers will find evidence here to support his suspicion that so-and-so is a fraud, whereas his favorite director is a master of his art and a craftsman without peer. But our ideal reader is the critic whom we hope to persuade to approach the film experience on its own terms, in its own language, and from less visceral and literary coigns of vantage than is common.

Any association of the term "language" with the film form is likely, at this time, to draw dour reservations from the film literates who have rightly resisted the glib oversimplifications of Frame-equals-Word, Shot-equals-Sentence, and Sequence-equals-Paragraph. But the film *is* a language in the broader sense of being a complete organization of experience shaped by the purposes of the communicator, the nature of the audience, the characteristics of the event to be communicated, and the organic mechanics and limitations of the communicative plastic. Film is a language like Dance, or Painting—not like Japanese or French.

To illustrate the distinction being made, let us imagine that I had been a witness to a robbery and wanted (for reasons of good citizenship or ill humor) to inform someone about it. I might go at the task in any of several ways. I might choose to tell someone about it in words, in which case I might use English or I might use French. The choice here would be one of convenience and the recognition of common encode–decode skills, and the language used would depend on whether the robbery had taken place in Paris or Spokane. On the other hand, I might not use words at all; I might choose to sketch on paper a diagram of what had happened, or do a mime dance reproducing the event;[1] or I might even make a film about it. These latter choices would be made on the more significant level of my purpose for making the communication, the media available to me, the makeup of the audience— not on the smaller level of common language.

Any language, in this larger sense, undergoes organic evolution and development. These changes are functions of the purpose and creativity of the communicator, the basic nature of the event being communicated, and the level of literate skill in the audience member. We recognize great differences between the painting of Lippi and Mondriaan. Primitive tribal dances little resemble the *Ballet russe* (although, if we consider modern popular dance, we have cause to suspect that there is something cyclic in the development of this language). And the heated discussions of our espresso aesthetes demonstrate that there has been radical change in the language of the cinema between Griffith and Antonioni. Only the

[1] Indeed, one of film's finest moments was just such a reenactment of a crime by Jean-Louis Barrault in Carné's classic, LES ENFANTS DU PARADIS.

verbal language remains fairly stable. It is possible that the relatively slow rate of change in word-based languages has something to do with the fact that, since the word-worshiping days of medieval scholarship, the concepts of "knowledge" and "words" have become commingled, and few dare to tamper with the vessel of knowledge. (In the beginning there was the *vision?* Yes, of course. But we never say so.)

The burden of carrying all knowledge has weighed heavily on the creative arm of the verbal mode, preventing it from speaking to our age with the immediacy and impact of the other languages, and this might account for the popular rise of these other languages which, historically, were reserved for the cognoscenti. (And a good thing too, Ortega y Gasset would have us believe.)

The fact that the film language seems to be in a greater state of flux than other communicative modes speaks well for its appeal to the modern audience, but at the same time it poisons the well of this little book. Any attempt to freeze and catalog the organic and changing elements of the motion picture for purposes of examination is likely to be incomplete, if not more palpably invalid. One always dreads bashing at the living whole of the film with the brutish tools of analysis, but at least the reader has the promise that categories will remain sufficiently loose so as not to strangle the events and experiences under consideration.

Rather in the way that nature detests a vacuum, the imaginative mind flees from the restrictions of the dichotomy and seeks the comfort of the first available *tertium quid*. Creative film makers and critics have responded to earlier versions of this manuscript in just that way, saying: "That's very interesting, but I can think of a case in which. . . ." And it is perfectly proper that they should do this. It is all very well for logicians and advertising consultants to analyze and say that such and such a thing is either this or that, but in the real world of art and life events tend to take on the complex characteristics of the men who make them and of the conditions that make the men. So the analytic parts of this book will treat its neat separations into rubrics as fictions—valid only insofar as they are useful to the film maker, viewer, or critic; useful only insofar as they cast some light on the event without blinding the observer to the alternatives.

Table of Contents

The Language
of Film

1

Of Language, Form, and Function

The word "language" usually refers to the verbal mode of communication. We speak of the written or the spoken language, be it French or Swahili. But the term is used quite differently and with grander connotations when one speaks of "the language of love" or of "the language of the dance."

In the more common usage, the differences between two languages are matters of symbol formation and arrangement. The major differences between a written and a spoken language are that the first uses visual symbols arranged in space, while the latter uses audio symbols arranged in time. And, despite the allegations of the Académie française, the principal difference between French and Swahili lies in the symbol used to stand for a concept. The French language is much more closely related to the Swahili language than it is to "the language of dance" and even—bitter to report—to "the language of love."

When one deals with the differences between "the language of music" and "the language of film," he is coping with the greater and more basic matters of mode and channel—of the kinds of messages transferable and their coding patterns. And these are differences much more significant than changes in symbol formation and arrangement.

A study of language in this last sense involves descriptions of

the forms and patterns available to the communicator, and of the single and cumulative effects of these basic message increments. From a knowledge of these forms, patterns, and effects develops an understanding of the kind of messages appropriate to the medium and of the ways in which the communicator cooperates with his medium in the organization and arrangement of these elèments into total and effective communications. It seems that the first step in the analysis of a communication, the criticism of a message, or the creation of a statement should be a full understanding of the formal elements of the language, although we must allow that this understanding might be intuitive in the case of the creative communicator.

Of Form and Content

After reading through criticisms of the various media (painting, film, dance, literature), one is often left with the feeling that form and content are being dealt with as separate things, more or less as one might think of a bucketful of water as if the water were the content, and the bucket the form in which it is carried from place to place. This dualistic view of communication is one of those useful fictions—useful insofar as it allows the critic or the self-criticizing artist to pinpoint a moment in the ongoing communicative event for comment and improvement; a fiction because the real relationship between form and content lies somewhere between collateral and identical.

It is fashionable just now in communications study to take a polar position on the form–content continuum and to describe the message as though it were pure form (content being the effect of form on the viewer), or as though it were pure content (form being the inevitable constriction and arrangement imposed upon content by the mechanics of the medium).

Both polar postures have the virtue of allowing us to examine communications from fresh and often fertile points of view. Each has the drawback of misrepresenting the communicative event. To be sure, this is a trivial blemish in academe, but it is reassuring to notice that the scholars recognize the incompleteness of their polar views and seek to bridge the void by the Procrustean technique of defining what most people would call form as an aspect of content, or vice versa.

Surely no sensitive man has ever reacted to a Balzac novel as though it were a formal distribution of ink over a page, nor has he responded to a Bach fugue as though it were a series of wavelengths qualified by timbre and extended through time.

The suggestion that form and content are one is nearly as ludicrous as the postulation that they are discrete.[1] It seems most sensible to view the relation between form and content as being complementary. And there are at least two ways in which form cooperates with content: permissively and redundantly.

Certain forms may be said to permit the transfer of some kind of content and to prohibit (or at least impede) the transfer of other kinds. One cannot paint a tragedy, in the Aristotelian sense of the word. To term a painting "tragic" could only be a negative criticism of the painter—and that only through a stretch in the meaning of the word. Similarly, a visual description can be transferred through print only partially and at great loss of efficiency, as anyone who has staggered through the graphic passages of the *Comédie Humaine* or tried to visualize the arrangement of troops in the first book of *Les Misérables* will recall.

[1] In passing, it should be admitted that form and content come closest to identity in the visual-tactile arts: sculpture (the reduction or construction of a mass of matter into a predicted and effective form), and its near-relative, ballet (the description of form in space through the idioms of human movement).

After the limen of permission is crossed, form begins to relate to content redundantly. Anyone wanting to deal with the content of an El Greco would find need to mention the flamelike verticality of some of his figures. But verticality is clearly a matter of form. Or again, changes of tempo and volume (formal aspects of music) carry significant elements of the content of musical communications. And in literature we have poets who have departed from the oral tradition of verse (e. e. cummings, as the prototypical example) and who have made matters of formal layout on the page vital to the content of their messages.

The Functional Approach to Language

Whether one thinks of the content of a message as the intentions of the communicator or as the reactions of the receiver, content remains a subjective, qualitative, and practically unmeasurable concept. Form is less subjective; and for this reason analyses, criticisms, and studies of form are more likely to contribute to the perfection of the medium and to its understanding than are content studies which, at their best, decorate the original message with the thoughts of the critic and, at their worst, obscure the creator's thoughts in a tangle of amplifications and apologetics.

There are two ways to describe linguistic form: definitively and functionally. The first attempts to say what a form *is;* the second attempts to describe what it *does.* Speaking definitively of a line, one could say that it was the path of a point in motion. Functionally, in the graphic arts, the line is a device for connecting or separating areas, for creating flow and motion, and for dividing space into effective masses. It should be obvious

which of these descriptions of the formal aspects of line is most pertinent to the artist and the viewer.

Descriptions of the formal aspects of the verbal language (grammars) once tended to be definitive. The effects of this facile, narrow view of language would have been disastrous if the compulsive, nitpicking grammarians of the nineteenth century had not been rendered impotent by their own ludicrousness. (If they had had their way, remember, we would be required to call down the stairs, "If it be he, ask him to whom he wishes to speak.") Fortunately for the verbal language, a functional approach replaced the definitive, and today the grammarian is rare who would label the symbol constellation s-t-o-n-e as a common noun, or a proper noun, or a verb, or an adjective (any one of which it might be) unless he could examine it in its context.

The languages of music, painting, film, and the other arts have received much less attention, probably because a basic knowledge of the verbal language is necessary for survival in any society, and an individual can exist healthily and long (if not richly and pleasantly) with no knowledge of the other media. Possibly these other communicative arts have benefited from this lack of attention, considering the effects of formalization on the verbal medium.

But there are growing pressures now to take a more careful and formal look at the film language. Not only is the film generally accepted as a major art, but its stuttering offspring, television, is increasingly filling the earlier roles of press and radio, as well as some of the more burdensome "aspirin" functions of film as mass entertainment. The languages of film and television have many points of identity. Although the younger medium has chosen to operate like illustrated radio and turgid vaudeville and may long be prevented from adopting the communicative sophistications of its parent by its economic structure and audience composition, television possesses the formal

potentials to become a major creative medium. The first step in the eventual maturation of television will be a formal emulation of film, to which will be added a feeling for the special qualities of the television event (immediacy, for instance, and the vulnerable posture of the audience member). An even more urgent reason to study the language of film lies in the fact that more and more of the teaching of our children is being conducted through the audiovisual channels. They are being taught through a language they have never studied and, what is more frightening, through one that their teachers have never studied.

There is also the influence of the film form on the other arts —a phenomenon that has received little more than conversational attention. Dances are being choreographed in terms of camera angles; some novelists (notably Graham Greene) obviously write with inner filmic visions; and certain aspects of literary style can best be described in filmic terms, as in the case of Joyce's time–space treatment of a Guiness beer sign, which is best described as a "cutaway."

At the risk of offending literary people, it must be recognized that the language of film is vastly more complicated than the verbal language. After all, words are only one component of the total film message, and not the most important one at that. The verbal language is either arranged in space (written) or in time (spoken). Space arrangements permit the reader to slow down, even arrest, the flow of the message while he works out meaning and intent. The time arrangements of speech, while vastly more complicated and difficult to analyze than print, which historically is a recording device for speech, possess the illuminating bias controls of inflection, grouping, volume, and immediate feedback and criticism, all of which serve to guide and facilitate understanding. In the film, which operates in time and space simultaneously, spoken words, written words, compositions, angles, lighting, histrionics, music, background sounds, montages—many content elements wash over the

viewer, and the message flows on steadily, out of the control of the receiver.[2]

So this essay will approach the language of film functionally. It will avoid saying "this is what the filmic element is." It will attempt to say, "this is what it seems to do." And since we believe that the filmic expression developed its syntax in direct response to its peculiar content, audience, and communicative machinery, we shall begin with a look at these formative forces.

[2] It has been suggested that I correct these lines to admit that the film scholar, with the use of viewing and analysis devices, could indeed arrest and control the message and examine it minutely for content. This is certainly true. It is also what is wrong with most content analyses of film. The scholar, with his lust to mention all and to quantify everything, views the film under conditions totally alien to the normal experience of the audience member, and he discovers "content" and "themes" and "styles" that exist only in the hot-house of academic publication.

2

Genesis: The Inevitable Machine

There is no reasonable doubt but that the credit for the invention of the motion picture goes to the wizard of Menlo Park.

It was Eadweard Muybridge who really invented the motion picture.

The laurels for the invention of the motion picture must be placed on the brow of Etienne Jules Marey.

W. K. Laurie Dickson invented the motion picture.

Max Skladanowsky invented the motion picture.

Johannes Zahn invented the motion picture.

Louis Le Prince (tragic and mystic figure) invented the motion picture.

William Friese-Greene invented the motion picture.

What about the Lumière boys?

. . . and on it goes, the scholarly hassle to place the technological credit (and sociological blame?) for the film upon some one person. Each historian fixes the race by the Procrustean technique of excluding the other contenders through a rigid definition of just what constitutes the first motion picture. To this end, they heap on qualifications like: stroboscopic effect, strip film, Maltese cross, shutter–shuttle assemblies, projection, paying audiences, and existing filmic evidence.[1] The

[1] A good look at these discussions of "who got there first" appears in G. Michel Coissac, *Histoire du cinématographe* (Paris: Editions du "Cinéopse" et Gauthiers-Villars, 1925).

fact is, it really does not matter, not to the film maker or the student of the film form. More important are the particular antecedent communicative climates, the new audiences, the new content, and the new developments in image reproduction and motion study that all intersected at the end of the last century to create the language of the film.

Carlyle notwithstanding, it would seem that times produce their heroes—when a society needs a leader, it gives birth to one. The choice of one from among the many willing candidates may, however, be made in Nietzsche–Carlyle terms.

Similarly, it could be proposed that the need for a communication appropriate to the mass audience, for one that could present a semblance of realism, for one that could deal with surreal abstraction, demanded the technological birth of its apparatus. The many scientific, artistic, and mechanical midwives who contributed to the delivery (often obliquely, usually inadvertently) are of less moment than the audience, the content, and the form that determined the nature of the motion picture and made it an inevitable machine.

From the middle of the nineteenth century to the advent of cinema, there existed a communicative vacuum. The Industrial Revolution had produced leisure time as an inadvertent by-product and had created an audience whose size and character the theater was unequipped and unprepared to satisfy. When Toynbee published his well-known description of the explosive effects of the Industrial Revolution on population in England, he was delineating patterns that would obtain in each industrial nation that followed England's march toward the machine. Although his statistics have come under some criticism, no one doubts that he was describing quite accurately the frightful acceleration of population, the depopulation of illiterate rural areas, and the concentration of masses in the cities—all of which were characteristic effects of the factory.[2]

[2] Arnold Toynbee, *Lectures on the Industrial Revolution of the 18th Century in England* (London: Longmans, Green & Co. Ltd., 1884).

At first, Father Arkwright's children could hardly be described as a potential audience. So total was their bondage to the machine that, as late as the middle of the century, they had little time for sleep, much less for recreation.[3] But the English Factory Act of 1833 and subsequent legislation in Britain and on the continent brought a modicum of free time to the laboring masses. In the United States, for instance, leisure time for workers tripled between 1840 and 1930. And this leisure, coupled with a steadily rising literacy, converted the mass man into the mass audience member.[4]

Now the theater, with its necessary spatial limitations, its economic restrictions, and its middle-class orientation neither desired to gratify nor was capable of gratifying this new audience. By the end of the century, there was a vast audience all dressed up with no place to go.

The monumental social changes that created a new audience also produced a new content—new messages. Concern with rising classes and the social problems they faced and the Darwinian realization that human condition and behavior were somehow linked to environment combined to hasten the end of romanticism. Sicklied o'er with the pale cast of thought, romanticism turned its face to the wall, contemplated remembered sylvan vistas, heaved a shuddering sigh, and died, b'God. And realism was upon us.

Realism may be viewed as the logical effect of the positivism of Comte and the developmental concepts of Darwin on the creative work of novelists and, later, playwrights. No doubt an honest concern for human suffering played as great a

[3] For the more touching cases of this, those affecting children, see: "Report of Committee on Factory Children's Labour," *Parliamentary Papers* (1831–32). And, "Report of Children's Employment Commission, Mines, 1842," *Parliamentary Papers* (1842).

[4] Interesting glances at the role of entertainment in the working classes are found in: Richard Hoggart, *The Uses of Literacy* (London: Chatto & Windus Ltd., 1959); and, Martin H. Neumeyer, *Leisure and Recreation* (New York: The Ronald Press Company, 1936).

role in the maintenance of the realistic style as did the economic gain resulting from the sensationalism of the movement. On its brightest side, realism produced the plays of Scribe, Ibsen, Chekhov, and Dumas *fils;* the refreshing teamwork of the Saxe-Meiningen company; and the Independent Theater movement that culminated in the Moscow Art Theater of Nemirovich-Danchenko and Stanislavsky. Modern film acting owes a great debt to the identificational acting style advanced by this last. On its darker side, realism carried the burden of its *reductio ad absurdum:* naturalism, which came into the theater briefly with Strindberg in *Miss Julie* and disastrously with Zola's adaptation of his novel *Thérèse Raquin* in 1873. The crippling effects of Comte's limited view of "The Real" reached their zenith in the productions of David Belasco when an entire boardinghouse room was brought intact and set up on stage for his *The Easiest Way,* or when he created an exact replica of Child's restaurant for *The Governor's Lady,* or when he pumped the smell of coffee through the theater's ventilation system to reinforce a coffee-drinking scene. Naturalism did not last long on stage. This last interphase in the development of realism into modern theater fell of its own weight because, as any stage designer knows, it simply does not work. The thing most likely to look like a false tree from the back of a house is, under theater lights, a tree. Concern with the real and the natural remained, but it left the theater for film, where images of the real were native to the mechanics of the medium.

So, at the advent of the film form, the content of realism and naturalism had outgrown the restricted forms available and was poised, waiting to be carried in the envelope of the new medium. But Darwin–realism was not the only content vacuum into which film rushed. There was also what might be called Freud–surrealism.

If not at the birth of the film, certainly during its infancy there was afield an artistic interest in the creative implications of the special reality of the subjective mind. In abstract paint-

ing, in stream-of-consciousness literature, and in the theater of Maeterlinck we find attempts to impart subjective and meaningful distortions of surface reality to expose an inner, putatively greater, reality. As a presentational art, theater creaked under the attempt to make the visual distortions necessary. Settings could be rendered abstractly, to be sure, and lighting could be dimmed beyond the threshold of recognition, but the basic mechanics of the medium could not cope with the time–space distortion necessary for a free presentation of the subjective, dreamlike state. The story of how theater throughout its history has struggled with the simple (for film) matter of appearances and disappearances is an epic of sweat, ingenuity, and failure.[5] Collages of events, superimpositions, flash changes in time and space—all the effects vital to the presentation of the subjective state were, for theater, dependent on the state of preparedness the audience member had gotten himself into at the pub around the corner. What theater could do only with supreme effort and scant effect, film could do as a matter of course.

Two levels of reality, the physically real and the psychically real, were messages without envelopes before film appeared at the turn of the century. There was a new audience with new interests and demands. Into these two streams flowed the third element, scientific and artistic concern with matters of motion. The confluence of these three factors was to carry film on to be the most significant creative medium of the twentieth century.

Since the Egyptian calendar makers, problems of motion and time have been intermingled. Time is read in terms of motion —the motion of the earth on its axis, or of the earth around the sun. And distance is also bound into the complex of time and motion. Astronomic distances are recorded in terms of the time necessary for light to travel from one point to another.

[5] The extravagant lengths to which stage designers went to cause an actor to emerge through the floor with some degree of subtlety are manifest in the Rube Goldberg machinery of the Corsican Trap (or Ghost Glide).

On a more earthly scale, we equally well say that one place is so many miles from another, or so many hours away by auto or plane.

Despite the scientific interest in motion, there was, before cinema, no accurate way to break motion through time down into its parts for study. In trying to accomplish this, Marey and Muybridge made their direct, if inadvertent, contributions to the development of the motion picture.

Eventually, the visual arts came to share science's absorption with motion. There were attempts to find ways of including the experience of movement with those of line, mass, form, and color in creative work.[6] The *Realist Manifesto* by Gabo said in part, "We renounce the thousand-year-old delusion in art that held the static rhythms as the only elements of the plastic and pictorial arts." And the *Manifesto of Futurist Painting* issued by Boccioni, Carra, Balla, and whoever else was around that afternoon declared, ". . . that universal dynamism must be rendered as dynamic sensation; that movement and light destroy the substance of objects." Interest in motion eventually led to the constructions of Vladimir Tatlin, the mobiles of Duchamp and Calder, the scrolls of Viking Eggeling, and the use of the motion picture for artistic expression by Hans Richter, Duchamp, Dali, and others.

To be sure, the element of motion in art, or at least of implications of motion, dates from cave paintings in which beasts are seen with five legs, one of which indicates the position of another at a later time in movement. Greek friezes reveal their narrative implications through time, and in order to decipher them, one must move relative to them. In painting and sculpture from the earliest times we find implications of motion— figures caught in flight or pictured with muscles tensed on the verge of an expected and inevitable movement.

[6] *See* Gyorgy Kepes, ed., *The Nature and Art of Motion* (New York: George Braziller, Inc., 1965).

But all these are examples of dynamic movement—of what the futurists were later to call dynamism: pent-up energy ready to reveal itself in motion. An artistic concern with real kinetic movement did not come to the surface (outside of dance) until the work and studies of Richter and Eggeling just after the Great War. It was fortunate for both art and the cinema that the film form was available as a tool of expression at the time when artists were seeking ways to organize motion into art—the first really new tool in graphic art since oil.[7]

So, in the areas of audience (mass), content (realism and sur-realism), and form (motion–time), there existed a total or partial communicative vacuum at the end of the nineteenth century. That the existing modes were valiantly, if unsuccessfully, attempting to carry new messages in old skins can be seen in the novels inflated with insufferable microscopic descriptions of every stick of furniture and scrap of wallpaper; in the theater where stage floors literally groaned under the weight of real trains rolling over real tracks, to stop just short of bisecting not very real heroines; in the abortive attempts to toy about with the effects of motion on canvas, such as "Nude Descending a Staircase" which, when inflicted on the patently unready patrons of the 1913 New York Armory Show, caused as near a thing to panic and riot as the weary people were capable of.

[7] Richter once mentioned that he had had no real interest in the cinema before he started to work in the medium. Indeed, at first he resisted Eggeling's suggestions that they explore the film as a method of recording and showing forms in motion. If there had been some other way to accomplish this, it is probable that neither man would have chosen the complicated chemistry of film.

Later I asked Richter why, in his view, artists had ignored kinetic motion as an expressive possibility for so long. He responded that he did not, of course, know; but he guessed it was because motion was a relatively insignificant part of experience before transportation and communication were improved by science to a point at which the world around the artist was in fact one in almost constant motion. Whatever the reason, it is true that motion in art suddenly appears around 1919 almost without harbinger, save for the "multiple exposure" approaches to dynamic motion of Duchamp ("Nude Descending a Staircase") and Balla ("Dog on a Leash") of half a dozen years earlier.

The rapid growth in use and popularity of the film form is scarcely surprising when we recognize that each of its technological ingredients addressed itself to the satisfaction of one of the needs obtaining in the communicative vacuum. The technological bases of the motion picture were photography, projection, and stroboscopic motion. Projection satisfied the mass audience. Photography, together with lens distortion and superimposition and editing, was the ideal vehicle for the real and the surreal. And stroboscopic motion furnished a way to deal with the problems and messages of motion.

The language of the film developed as a function of the message and the machinery; and therefore a glance at the development of the machinery constitutes a necessary prelude to any description of the language.

For a time in their prehistories, photography and projection shared common ancestors, before they branched apart. In his splendid picture book of filmic incunabula, C. W. Ceram reminds us that thoughts concerning realistic images and their projection were not alien to the mind of Heron of Alexandria as early as A.D. 125.[8] Actually, there is every reason to suspect that Euclid and Ptolemy might have known something about the camera obscura, at least of its use for observing the sun during eclipses. Both men wrote on optics, but neither document survived the burning of the library at Alexandria. However, there is in the Bibliothèque nationale in Paris a Latin translation of the Arab scholar Al-Hazan's (A.D. 965–1038) commentaries on Ptolemy's optics, and elsewhere he shows knowledge of the workings of the camera obscura, and even of certain refinements of projection through mirrors.[9]

The *camera obscura immobilis* was just what its name implies, a dark room that didn't go anywhere. A hole was cut in one wall and through it light fell on the surface opposite. If

[8] C. W. Ceram, *Archaeology of Cinema* (New York: Harcourt, Brace & World, Inc., 1965).
[9] *See* Bibliothèque nationale, document #3.710.

the scene outside the room were in bright enough sunlight, an image of that scene, upside down and right for left, would be visible on the wall opposite the hole. The farther the screen surface was from the hole, the larger the image. Such men as Roger Bacon, Leonardo da Vinci, and Jean-Baptiste Della Porta knew of the device and described it. And Della Porta suggested the use of the camera obscura for copying nature, doing portraits, and capturing landscapes. The device was used for just such purposes as soon as a portable version was developed by Athanasius Kircher (1601–80) and Johann Kepler (1571–1630). A little later a reflex version of the camera obscura was produced by Johann Christoph Sturm, and it quickly became a popular tool for aiding the artist in rendering nature with precision.

Of course, it was only the room-sized *camera obscura immobilis* that possessed the possibility of an audience, so from that point the history of photography goes on its own course, to rejoin the stream of projection at a later time.

It seems likely that Johann Heinrich Schulze (1687–1744) was the first man to isolate and use for reproduction the effect of light on silver salts. It is true that Albertus Magnus (1193–1280) knew that silver nitrate becomes dark under certain conditions, and that Angelo Sala—more than a hundred years before Schulze's experiments, had decided that the sun had something to do with this change of color, but neither man had any idea of using the phenomenon to make images, and it is doubtful that Sala ever separated the effect of heat from that of light in his exposures to the sun. Schulze's "photographs" were produced in a liquid suspension of silver salts and were, obviously, not permanent; but he managed to make impressions of word cutouts. In his carefully documented and very readable *Concise History of Photography*,[10] Helmut Gernsheim amus-

[10] Helmut Gernsheim, *The History of Photography* (London and New York: Oxford University Press, 1955).

ingly touches upon the similarity between Schulze's "writing with light" and the literal translation of "photo-graphy," but he has the good sense to quickly mention that the term "photography" was not introduced for more than a hundred years after the Schulze experiments.

It was Thomas Wedgwood (1771–1805), son of the potter, who came upon the idea of blending Schulze's research with the concept of the camera obscura to the end of making images from nature. However, he was unsuccessful—the light produced by the camera obscura being insufficiently strong to affect the emulsion.

Building on the work of the German and the Englishman, it was a Frenchman, Joseph Nicéphore Niepce, who produced the first true photograph. As early as 1816 he made negative images by means of the camera obscura, but they were impermanent. The first permanent photograph—on pewter—was made either in 1824 or 1826.[11] It is a bit of rare good luck (and the energy of Helmut Gernsheim) that accounts for this historic photographic document's being available to the scholar, for no other photograph by Niepce exists.[12]

A short time later Niepce entered into partnership (not without reservations) with Louis Jacques Mandé Daguerre, whose name the general public associates with the invention of photography. That Daguerre replaced Niepce in the popular mind was probably caused by Daguerre's contacts in the French Academy and by the fact that Niepce died before the rage for daguerreotypes began. Whatever injustice this displacement might have done to the fame of Niepce has been abundantly repaid in recent years as scholars, in their zeal to set things straight, have dealt with Daguerre as though he were some-

[11] The former date has been common for historians of photography following the accounts of Niepce's son, Isidore. But Mr. Gernsheim makes so excellent a case for 1826 that it is probable that this date will henceforth be accepted.

[12] This rarest of all photographs now rests in the Gernsheim Collection at the University of Texas.

thing between a thief and a hustler. Actually, Daguerre's inventiveness and aptitude for promotion had as much to do with the popularity of photography as had any contribution by Niepce. And if Niepce's family ended in straitened circumstances while Daguerre's name became a household word, the blame lies more with public insouciance than with any attempt on Daguerre's part to cloud the issue of precedence.

As soon as the camera was sufficiently perfected, it was set to the task of capturing reality. Naturalism in photography found early use in portraiture. So rapidly did interest in the camera as a device for inflicting one's image on his progeny develop that it all but replaced miniature painting. In 1859, for the first time, no miniatures appeared in the Royal Academy Exhibition. Another use of naturalistic photography was the bringing of faraway places to the stay-at-home viewer. As early as 1861 we find August Bresson taking magnificent shots of Mont Blanc. Charles Clifford brought the landscapes of Spain into the living rooms of Victorian homes; Dr. Robert MacPherson did the same for Rome; Samuel Bourne photographed the Himalayas; and Francis Firth produced stereoscopic views of the Middle East. This growing interest in distant lands was to develop in cinema into the travelogue, the documentary, and the general penchant for exotic settings.

Marc Antoine Gaudin must be given credit for instantaneous photography (although not quite so "instantaneous" as he claimed) by virtue of his shot of the Pont Neuf shown to the Académie des sciences in October of 1841. Without short exposure times, the motion picture would never have been possible. This development of instantaneous photography led to the "news" pictures of such men as Roger Fenton in the Crimean War and Matthew B. Brady in the American Civil War—both of whom often dwelt on the kinds of naturalistic horrors calculated to feed the popular appetite.

Almost from its beginnings, the motion picture was to capitalize on spectacle and combat, two lines of visual content that

can be traced from Delacroix and Gros, to Fenton and Brady, to Griffith and George Stevens.

Another harbinger of the filmic mode was the blending of the real and the surreal found in the work (both photography and books) of P. H. Emerson. This leader of the enthusiastically received naturalistic school of photography included artistic distortions and softenings of a dreamlike quality in his definition of "naturalism" as offered in his *Naturalistic Photography* of 1889.

Never had a public taken to an invention with such enthusiasm as it did to photography. In the years that followed its introduction, photography became a business, an art, a hobby, and a science. Photographs were taken on metal, ceramics, glass, and paper. The daguerreotype gave way to the calotype; collodion gave way to gelatine. Cameras became less bulky, less complicated, less expensive, and more dependable. Finally daylight loading came into being: George Eastman told the world, "You press the button, we do the rest"; and no awkwardly grinning vacationer was safe from the eyes of derisive grandchildren. In August of 1905 the *Daily Mail* estimated that there was one amateur photographer for each ten people of all ages in England.

From the point of view of the coming motion picture, the most significant among all these technical improvements was the development of a flexible transparent film. Alexander Parks was the first to patent the use of celluloid as a film base in 1856, but he never developed the process to a practical level, so other men pressed forward in the study of other flexible bases, typically combinations of gelatine and collodion. It was not, however, until John Wesley Hyatt of the Celluloid Manufacturing Company managed to produce clear sheets of celluloid of a uniform thickness in 1888 that a valid solution to the problem appeared. A New Jersey clergyman, Hannibal Goodwin, was the first to apply for a patent on the use of celluloid strips for photographic purposes, and his subsequent

successful battle with the Eastman-Kodak Company for priority rights is an epic of Patelinism. Prior claim or not, it was George Eastman who made the new film base available in quantity and who popularized its use in photography.

Any raw plastic appropriate to moving pictures had to have many qualities, each of which presented technical puzzles. The substance had to be transparent, or projection would have been difficult; it had to be strong, or it would rip under the pressures of the mechanisms for moving it through the camera; and it had to be flexible so that it could be carried economically on spools and make the tortuous serpentine path through camera and projector. The nitrocellulose (and later cellulose acetate) base responded to all of these specifications. The vast importance of the substance to the development of the motion picture and its language can be seen in the fact that "motion picture" and "film" are synonymous, not only in the industry, but in criticism and history. No one ever considered calling painting "canvas" or making "paper" a synonym for literature.[13]

On the eve of the motion picture, photography had made sufficient advances to make possible the new medium. Principles of projection were also far enough along to be used in the fresh blend.

The use of projection for communication is as old as the heliograph. Della Porta used the camera obscura to conjure up "deviltries" for an audience within the room by having an actor or dancer do his bit before the opening in the wall. But neither of these was a direct ancestor to the kind of projection that led to the motion picture. The first did not deal with the projection of images, and the second placed the viewer inside the camera—an awkward seating arrangement, if applied to modern cinema. There is also the matter of the inverted image.

[13] There is vestigial reverence for the medium in the fact that one paints a "canvas" or reads a "paper" at a convention.

There is no evidence that Della Porta used (or knew of) an inverting lens to set his images rightside up.[14]

Paternity for the first modern projecting device, the magic lantern, is variously bestowed by historians on Athanasius Kircher and Christian Huygens. Such light controversy as there is here centers around dates of publication. In the first edition of his *Ars magna lucis et umbrae* in 1646, Kircher makes no mention of the projecting lantern, but in the second edition of 1671 there is a description of a device that could project images. Between these two dates, in 1656, the ubiquitous Dutch physicist Huygens described a machine for the same purpose. If one enjoys puns, it is convenient to call the Jesuit Kircher the "Father of the Magic Lantern," but I find it easier to ascribe the device to the prolific Huygens who also founded the undulatory theory of light, the theory of probabilities, who discovered the rings of Saturn, laid down the principle of centrifugal force, and invented the pendulum clock.[15]

Whoever first conceived of the magic lantern, it was the Premonstratensian monk Johannes Zahn who refined the device and added a primitive form of motion with a mobile disk in front of the lens.[16] And with no significant technological changes, Zahn's projector was popularized in the late eighteenth century by the Belgian E. G. Robertson (real name: Etienne

[14] The early uses of the projector by men who were both scientists and priests dealt with the reproduction of supernatural objects: devils, gargoyles, ghosts. In a way, the modern horror and science fiction potboilers have a greater claim on that antiquity that scholars so worship than have, for instance, the films of Antonioni. To be sure, the motives of the money hustlers who make thrill and spook shows for the bored and unimaginative masses are probably not overly noble. On the other hand, the coercion of people into righteousness by promissory notes written on purgatory might not have been significantly nobler.

[15] Just as one may safely ascribe any doubtful quote to Shakespeare, Pope, or the Bible with reasonable assurance of accuracy, so may any significant scientific breakthrough be credited to Leonardo or Huygens with comfortable odds in one's favor. Indeed, the concept of the condensing lens, so vital to any projector, was one of the many anticipations attributed to Leonardo.

[16] Zahn, *Occulis artificialis teledioptricus,* 1685.

Gaspard Robert). If contemporary drawings are to be credited, Robertson's rear-projected shows, the Phantasmagoria, caused men to gasp and recoil and ladies to swoon with fear. Robertson added a kind of motion beyond the movable disk of Zahn; his lantern was mounted on what looks like a tea cart with large wooden wheels covered with rubber to make them silent. By rolling the cart toward or away from the screen, he could cause his figures to loom bigger or to grow smaller. There is also the possibility that he could "pan" his projector to cause images to move across the screen. In both cases he must have had follow-focus problems that any modern cameraman would respect. There is no doubt that the eeriness of Robertson's spook shows was reinforced by the setting he chose for his audience, an abandoned and partially ruined monastery off the Place Vendôme.

In England in the 1840's, H. L. Child heightened the effect by the use of two more lanterns. Images could be moved about independently; superimpositions could be affected; and one image could dissolve into another by irising out one lantern and irising in another. The name "dissolving views" was given to this popular technique.

Itinerant magic lantern men, often mountebanks and hustlers, brought the device around the world, delighting audiences in such unlikely places as the China coast, North Africa, and the banks of the Mississippi. When the lantern was set to the respectable task of illustrating travel talks and moral lectures, it became a permanent feature of the meeting-hall circuits. Home models were invented, and with the stereoscopic viewer it lightened turgid puritan Sundays in padded middle-class parlors. Throughout its history the magic lantern had a predominantly middle-class audience. Its working class opposite number was the pull-string peep show that offered the mass audience everything from Punch to pornography. It was not until the advent of the cinema that projection and the mass audience met.

After photography and projection, the third factor that contributed to the development of the motion picture and shaped its subsequent language was a scientific and artistic concern with motion. Two main streams can be discerned in motion study: the recording of motion as it flowed over the still photographic plate, and the production of the effect of motion through the mechanics of the stroboscope and the phenomenon of the persistence of retinal impressions.

The names of the devices developed in the nineteenth century to demonstrate the effect of realistic motion through persistence of vision read like a Verne nightmare: the Thaumatrope, the Zoëscope, the Zoëtrope, the Stroboscope, the Phantascope, the Phantasmascope, the Phenakistiscope, the Choreutoscope, the Praxinoscope, the Stereothaumatrope, the Chromascope, the Eidotrope, the Kinestiscope, the Phosmatrope, and many others, most of which are now only descriptions on long forgotten patent applications. Few of these devices contributed to the main line of the projection of series photography; many of them were only mild improvements on previous machines; but all of them attest to a great and general interest in the phenomenon of motion.

In 1823 Dr. John Paris described a visual toy he called the thaumatrope. It was a disk, usually of cardboard, with loops of string so attached that it could be spun rapidly when the twisted strings were pulled. On one side of the disk, an image was drawn—such as a bird. On the other, another image appeared—such as a birdcage. The visual effect was one of superimposition; the bird appeared to be in the birdcage. And many variants of this parlor bauble appeared. The thaumatrope could hardly be considered a step in the devolpment of the cinema because it was impossible to show motion with it, but the device demonstrated the principle of the persistence of vision, a phenomenon which Faraday and Roget had been studying and upon which the illusion of motion in the cinema is based.

Several years after Paris, Joseph Antoine Plateau published his studies of the persistence of vision in which he said that the eye tends to hold an image on the retina for a short while after the source of stimulation is gone. In 1836 he made the logical extension of his work by demonstrating that if images or slightly advanced stages of motion were caused to fall on the retina discretely and with sufficient frequency (at least sixteen times per second), the figure would appear to perform the motion recorded. It was at the moment of this realization that the motion of the cinema was born.[17]

Only a little later than Plateau, and totally independently, the Austrian Simon Stampfer developed a device for giving the illusion of motion to series pictures. Both men used drawings of simple actions, each drawing showing the action slightly advanced from the preceding one. In both cases, slotted disks were revolved to cause the images to appear one after the other and to give an effect not unlike the viewing of a man doing some simple exercise as seen through a wagon wheel revolving so fast that it appears to go backward.

It was not long before some enterprising mind (in this case Franz von Uchatius's) would think of combining the moving images with the magic lantern to produce projected moving pictures (although not yet photographs).[18]

A more sophisticated and very popular device for projecting moving drawings was invented by Emil Reynaud. His praxinoscope had a double projection system; one for rear-projecting the backgrounds, and one for rear-projecting the images moving over these backgrounds. Using perforated film, Reynaud con-

[17] Fate has dealt ironically with many of cinema's major contributors, as the later lives of Méliès and Griffith and the death of Eastman attest to. Plateau, the scholar of the persistence of vision, was completely blind by the time he was thirty-nine as a result of the strain his studies placed on his eyes.

[18] Apropos of the preceding footnote, von Uchatius later became so dejected over his inability to produce even larger cannon for the German army that he shot himself.

tinued to delight audiences with his *Théâtre optique* until well after the advent of the true motion picture.

Eventually, the stroboscopic devices for making an illusion of motion were applied to posed series photographs, rather than drawings; but it was not possible to actually photograph motion in a way suitable to projection until film emulsions were developed that allowed one to make exposures of less than one-sixteenth of a second. The endless interest in the task of photographing things in motion demonstrated by Muybridge, Janssen, and Marey was to fill the last gap remaining in the development of the motion picture.

In 1874 the French astronomer Pierre Jules César Janssen used photography to record the passing of Venus. His device involved a rotating plate whose motion was stopped by a Maltese-cross mechanism for the time necessary to take a photograph. It was not long before others interested in the study of motion saw the value of the photograph. A physician despite himself, Etienne Jules Marey, used a similar apparatus for studying the motion of birds in flight, but for a number of technical reasons he retreated temporarily from the use of photography and developed his chronograph to record the movements of a running horse. This instrument involved the attachment of small rubber balls to each hoof of the beast. Tubes leading from the balls carried air forced up by the weight of the horse, and this pressure was recorded on tracing needles. He must have believed that the shortest distance between two points was a cube.

At this juncture in the long story of the motion picture enters a figure whose life was as baroque as the spelling of his name: Eadweard Muybridge. Born in England with the somewhat more pedestrian name Edward James Muggeridge, he emigrated to America when he was quite young and eventually became a photographer in the service of the government in California. Part scientist, part con-man, part photographer, part carnival

barker, and part nut, Muybridge has left a trail of academic controversy and doubt behind him. His entrance into the arena has to do with the famous "Stanford-MacCrellish bet." In result of Marey's studies of the horse in motion, the French equestrian and artist Captain Duhousset produced a set of drawings, one of which showed a horse with only one hoof in contact with the ground. When these drawings found their way to California, they were held in some doubt by Governor Leland Stanford. At this point, the story clouds over. It is fairly likely that a bet concerning the matter was made between Governor Stanford and Mr. Frederick MacCrellish, but who was on which side is moot. It is also a matter of question whether the bet concerned a horse having only one hoof touching the turf at a moment in its running, or of its having no contact at all with the ground at one instant. In all events, Muybridge was invited or (more likely) volunteered to settle the matter. In 1872 at Governor Stanford's stables in Palo Alto a bank of cameras were spaced along the side of a track to be triggered one after the other as the horse ran past.[19] At first the triggering was done by strings, later automatically by electricity. An examination of the photographs (both blurred and underexposed) proved that while running, a horse did in fact have only one hoof in contact with the ground for an instant, and somebody or other won a bet.[20]

In 1878 Muybridge, the main chance never out of sight, published a pamphlet, *The Horse in Motion,* to which he later added illustrations of other animals and athletes in movement. The next year the enterprising man invented the Zoopraxiscope, a stroboscopic projector that permitted him to make wider use of his photographs. That same year he presented

[19] The horse was Stanford's racing trotter, Occident, who thus became the forerunner of Lassie, Rin Tin Tin, Tony and all the other animal stars.

[20] Modern scholarship tends to discredit the bet altogether. But let's hope that the romance of the idea will save it from the nitpicking of iconoclastic debunkers.

projected images of a running horse in Palo Alto and, in 1880, he offered the entertainment to audiences in San Francisco. In 1881 he toured Europe with his device at which time he met E. J. Marey, who was so taken with the Zoopraxiscope that he decided to return to the use of photography in his own studies of motion. After some pecuniary setbacks in his attempts to sell lavishly illustrated books on motion, the showman Muybridge opened his own exposition at the 1893 Chicago World's Fair, the "Zoopraxographical Hall." By the time he returned to England in 1900 to retire, Eadweard Muybridge had earned credit for the first projection of photographs that achieved the illusion of motion. But it must be mentioned that he never used film, he never devised a camera that would record motion, and he never went beyond the use of glass negatives and diapositives. These last vital steps were made by Etienne Jules Marey.

Without going into detailed descriptions of E. J. Marey's step-by-step development of a practical tool for recording motion, let it be said that he ended with a portable device which fed film steadily through a gate where it was arrested for the instant of the photograph—the principles upon which the modern motion picture camera operates, although Marey did not use perforated film. He also projected his films by means of electric light.

In the final years before the first true motion picture camera and projector—the Cinématographe of the brothers Lumière —there was a rush of inventions and inventors, all converging on the same objective. At the last minute, priorities became matters of months and weeks, and if one man had not done a certain thing, it is certain that another would have done it a short time later. In these climaxing years, the names of independent experimenters and technicians on the track of the motion picture are tangled in a kaleidoscope of "firsts" and "bests" that has given scholars and chauvinists unending material for argument. We find Anschütz, Le Prince, Friese-Greene, Edison, Goodwin, Eastman, Dickson, and others all

with tenable claims to "firsts," but popular history has singled out Auguste and Louis Lumière and their Cinématographe as a starting point in the annals of the motion picture. Almost every technological development that appeared in the Cinématographe was made by someone other than the Lumières. Other men projected motion pictures first, and for paying audiences too. But the Lumières deserve the credit and fame they have been given because without their business acumen and promotional sense, the motion picture might never have been more than one of the late Victorian spate of gadgets (as, indeed, many thought it was).

Not that the Cinématographe was an outstanding success with its first presentation. Perhaps it was because there had been a surfeit of mechanical and artistic novelties in the mauve-and-yellow Nineties—or perhaps the leaden and anticlimactic days between Christmas and New Year's are unpropitious for the introduction of anything requiring time and attention. Whatever the cause, only thirty-five people bothered to step off the wintry pavements of the Boulevard des Capucines that 28th day of December 1895 to pay a franc, descend into the gloom of the Indian Room of the Grand Café, and assist at the birth of the motion picture. Thirty-five people, thirty-five francs—and thirty of that went for rent on the hall. The Cinématographe Lumière gave little hint that it would develop into a multimillion dollar industry and into an instrument of art and information that would educate, delight, and enrich most of the civilized world.

The ten bits of filmic incunabula that made up that afternoon's fare were very short; they were poor enough in surface quality to win an award in Venice; and they were nearly as plotless as their wrong-side-of-the-blanket progeny, the television domestic comedy. But within these films a man of vigorous imagination can see the seeds of two of the three main lines of subsequent film development: the record film and the narrative film. The screen came alive with soldiers, the knocking

down of a wall, a baby eating with more vigor than grace, and workers leaving the Lumière factory (probably the first instance of mugging). And there was the rolling sea, and a train pulling into a station (with the thrusting diagonal composition that Porter and every subsequent competent film maker was to use in shooting passing trains), and an unforgettable game of cards complete with its kibitzer.[21] But most importantly, there was *motion*. The spirit of life had been breathed into the photograph. We are told that, in subsequent showings, ladies squealed and snatched up their skirts as they saw the ocean's waves lap toward them. It is possible that their desire to display a forgivable centimeter or two of ankle had as much to do with their reactions as had the new medium's realism, but there can be no doubt that artists and audiences alike were quickly aware of the potential and delight of the motion picture.

Technological developments in projection, photography, and stroboscopic motion drilled through the restraining wall that had held back the newly formed mass–leisure audience. Mechanical restrictions were removed, and the new content of realism and surrealism was unblocked. And the flood of filmic expression was unleashed.

Most early film was record; some was vaudeville turns. But soon came the fantasy of Méliès and the narratives of heroines and lean-jawed cowboys. Daring classic actors such as Bernhardt and Coquelin bestowed the benedictions of "art" on the neonate medium. Historical spectacle, sociological reflection, and Keystone Cops joined the flow of content, and after the Great War artists seeking to visualize beyond the limits of the canvas turned to the film.

Themes were to change, fashions were to ebb and flow, critical and scholarly attention was to elevate the flickering image to a high order of human communication, and the advent of

[21] For buffs and conversational one-upsmanship: The man who photographed these early films, and therefore the first cameraman, was one of the Lumière employees, Charles Moisson.

sound was yet to make its contribution to the new mode. But the instant of collision and fusion between this new audience, this new content, and this new medium contained all the energy and all the genetic potential that was to develop into the filmic expression.

3

Visual Content

For more than thirty years after its birth, the film language developed almost exclusively along visual lines. True, verbal titles were used to clarify the story line or, as in the case of Griffith, to point out a moral and give vent to his florid literary penchant. But the fact that a leanness of title was one of the salient features of the last and greatest moment of silent expression (the German "street film") attests to the essentially supernumerary quality of the read message.

Not that the viewing experience was silent! From the first, pit pianists blended their maudlin glissandi with the woes of the heroine, or pumped up excitement for the chase by thumping great handfuls of chords. For more formidable and pretentious films, such as BIRTH OF A NATION, entire scores were made available for prestige performances.

But this sound could not contribute in a controlled and predicted way to the audience's response to the film and so, until the DeForrest tube, the film developed as a visual medium, and its language remains today basically visual, the audio portions of the message serving, in the well-made film, to amplify, reinforce, or explain.[1]

[1] With the admitted exceptions of a few films in which the sound plays an independent, sometimes conflicting, role, such as: A NOUS, LA LIBERTE; LONELY BOY; and THE MOST.

So it is historically, artistically, and linguistically proper to treat first the visual aspects of the film.

In this section we shall deal with: the frame, composition, the shot, the sequence, editing devices, angle, lighting, color, image characteristics, camera movement, decor, and titling. In each instance, we shall try to describe the effects produced by the manipulation of these elements of the film language.

The Frame

The frame is a single, discrete, positive, translucent image connected to and separated from other frames in a film by a band of opaque emulsion. At first glance, the frame would seem to be the most basic carrier of content because most visual elements (a bottle, a window, a shadow, the expression on an actor's face) reside within its spatial limits. But in fact the frame may be dismissed as a content indicator in the film language because, in the viewing experience, it does not exist. The frame is motionless; the sound motion picture is a medium of motion. Also, all the visual elements that exist in the frame also exist in the shot.

To be sure, the still frame can be examined through the use of a viewer, and is so examined by the editor and by the content analyst, but any fragment of visual information that would be visible in the viewer, but not in the ongoing shot, can be considered too fleeting to have any effect on the audience member, save for the possibility of subliminal suggestion.

There are, however, two special forms of the frame (neither really frames at all) that require separate looking into: the positive promotional print, and the freeze frame.

Only most rarely is a frame used for advertisement and display purposes, but the stills that are used have all the characteristics of the frame and are thought of by the potential

audience member as excerpts from the film. To some degree these promotional stills operate as a part of the viewer's total film experience, at least insofar as they predispose him to view the film in a certain way and lead him to believe he will see a certain subject treated in a certain manner. It is general practice to select and display these stills (in newspapers, on theater facades, and in lobbies) in such a way as to attract the audience member. The selection and arrangement of these stills for the purpose of conditioning the audience member to view the film in some predicted and meaningful way is a matter for some future film maker to look into.

The linguistic uses of the freeze frame have received no formal attention before this time, largely because its popularity with experimental and professional film makers is a matter of recent fashion. Therefore, it will be dealt with at some modest length here.

The freeze frame is produced mechanically in the laboratory by reproducing the content of one frame on each of several adjoined frames, the number depending on the desired duration of the shot. Thus, the freeze frame is something of a hybrid between the frame and the shot. Essentially, however, it is a shot. The freeze frame endures on the screen: a quality of the shot, not of the frame. It also depends strongly on the principle of motion for its effectiveness, and motion is a property of the shot, not the frame. It may seem paradoxical that the freeze frame, which is motionless, depends on the principle of motion for its effect, but a moment's consideration will show that it is not. A painting or a photograph may be highly praised for having a feeling of motion, but never for having a feeling of stillness.[2] Motion and stillness are relative, and it is only in a medium lacking mechanical motion (like painting) that the effect of motion is significant. Similarly, the sudden absence of movement that is the impelling virtue of the freeze frame can

[2] We ought not confuse the calm of a Buffet or a Van Eyck with "stillness."

only be possible in a medium that permits of movement and that normally makes its content statements through movement.[3]

Finally, if any sound at all accompanies the freeze frame, it must be dealt with as though it were a shot. For mechanical reasons, sound is impossible without movement, in this case the motion of the film through the projector.

For these several reasons, the film maker and the analyst should think of the freeze frame as though it were a shot—but a shot containing a special, unreal, and mechanically obvious overtone of emotional and physical arrestment.

A mezzo-phase between the concept of the frame and the concept of composition is the linguistic element of "framing." Framing is the application of given boundaries to the experience before the camera. Sometimes, the feeling of framing precedes scripting and storyboarding. I recall a recent instance in which several of us, going over a proposal for a film, simultaneously agreed that the feelings here demanded the wide screen—and we had not yet read a single character description.

Framing operates with or against the compositional elements of the shot. When it operates with them, a feeling of balance and rest is gained. The audience member senses that all the forces bearing on the moment are within the limits of his screen, therefore within his immediate comprehension. When the frame operates against the compositional patterns in the field, a feeling of dynamic potential is aroused (if not a feeling of simple bad shooting). Constrictions, colliding lines, intersecting thrusts, kinesthetically disturbing imbalances are produced, and the audience member feels the pressure of things beyond the frame, or earlier in time, or later.[4]

[3] And, of course, the significant content of sudden silence had to await the advent of the sound film.

[4] It is a trademark of Hitchcock to make the audience member feel the presence of, and dread of, something just outside the frame edge.

So important to the film language is this matter of framing that it, together with camera movement, may be thought of as the major contribution of that most needed of men, the director of photography.

Composition

Composition is a much more complicated matter in the film language than it is in the static visual arts. Film composition has its foundations in the same principles as has composition in painting and still photography (satisfying balance, direction of the eye, and accent), and it uses similar devices for gaining these goals (line, mass, and intensity), but the film operates in time as well as in space, and it has the additional element of motion.

Satisfying balance (and its equally valid counterpart, meaningful imbalance) is accomplished instantaneously in painting through distributions of masses and intensities. The film need not limit itself to "the frozen moment" of painting. Because film extends through time, it can balance one shot against the next. Because it possesses the quality of motion, it can balance one part of a shot against the other, either through the moving camera or through the movement of subjects within the frame.

In a painting, the eye is directed almost exclusively through line and positioning in relation to masses and lines. In the film, the eye can be directed by these means, and by others: focus, field size, and motion. The first two are obvious; for the third one has only to recall the old theatrical principle that the moving object will attract the eye away from the still object.[5]

Linear elements of composition have certain traditional (pos-

[5] Like all other generalizations, this is not always true. If an unmoving object has overpowering narrative significance, it will hold the eye in all cases. For example, the dead monster in the beach sequence of LA DOLCE VITA.

sibly native) content implications. Verticals tend to imply action (the energetic soar of the Gothic cathedral). Horizontals tend to imply solidity (the rational lines of the Greek temple). Diagonals disturb the viewer's sense of rightness and imply chaos, instability, incompleteness, ongoingness (the hectic obliques of Hokusai, for instance, or of Brueghel). The film shares these content elements with the other visual arts; but it also has, through the effect of motion, *relative line*.

The movements of subjects across the field or the movement of the camera over a still field creates relative line thrusting in a direction opposite to that of the movement. Thus, if the camera pans from right to left, it creates a trail of horizontals thrusting from left to right. In this way the pan lends a feeling of solidity, relative to the tilt (a vertical movement), although any movement is less stable than is stillness.

The effect of panning through a pattern of vertical planes would be to speed up the motion but, at the same time, cancel the vertical (active) effect of the planes by the counteracting horizontal effect of the pan's relative line. A reverse effect would be created by tilting through a pattern of horizontal planes. For obvious reasons, panning along a pattern of horizontals does not increase their stable qualities. Indeed, under controlled shooting conditions, such a movement may be made to appear totally still.

We have thus far concerned ourselves with composing within the frame, and we have seen that the language of composition in film is very like that of composition in painting, except for the additional implications of movement and of time. The kinds of composition we have talked about are matters of framing, design, and camera blocking. But in the film there is also another aspect of composition in time: the editor's composition.

Whenever we are composing in terms of balancing one shot against the other, or blending (or colliding) the thrust of one action with another, or guiding the eye from shot to shot, these

compositional matters are ultimately in the hands of the editor.[6] Eye-guiding is the most delicate and difficult of these compositional effects. It normally requires a sense of where in the frame the audience member's focus is at the end of the shot, then cutting into the next shot with the center of action (or most important detail) at the same place in the frame. This, of course, is an oversimplification of the task of eye-guiding. There are times when the eye is intentionally left far away from the center of interest in the forthcoming shot in order to force the viewer to move over significant (but not predominate) material as his eye sweeps to the center of the next shot. We have also the matter of blending actions so that they seem to flow through the cut. When the eye is well guided and the action is well blended, the audience member is not aware of the cut. We call this a "soft cut." [7] When compositions and motions are not blended, a "hard cut" is produced. Although it normally takes more skill and experience to produce a series of soft cuts, the hard cut is not a bad thing, when you want it. It accents the cutting tempo (the visual counterpart of "beat" or "rhythm"). It also helps to reinforce feelings of chaos, fear, or hectic action. Later, in the section on montage and editing, we will speak of the effect of one shot on the next. The degree of that effect can be controlled in part by the hardness or softness of the cut.

In summary, composition in the film is not unlike composition in painting, but the film maker has the additional tools (and problems) of motion and time, and the additional compositional moment of editing. It is probable that composition is not so important an element of content (not form) in the

[6] By which I mean, they are handled at the moment of editing. Whether the ultimate decisions are made by the man called the editor is a matter of the style and control of the director.

[7] The term "soft cut" is used by some film makers (particularly on the West Coast) to designate a very short dissolve between two shots. This absence of catholic nomenclature is sometimes regrettable, but it is a by-product of the youth of the medium and its rapid change and growth.

film as it is in painting because of the repeated *tabula rasa* effect produced by the impact of shot washing over shot in the course of the film.

The Shot

Conventionally, the shot is defined as all the footage taken by one camera without interruption; film makers call this a "take." For people concerned with the viewing experience (the critic, the editor, or the analyst) the shot would be better defined as the total visual message produced from the editing of a take. Thus, if one continuous take were broken to insert another shot, and even if not a single frame were lost in the process, the two ends of the take would have to be dealt with as though they were different shots, because the viewing experience of the second part of the shot would be different from that of the first as a consequence of the conditioning and predispositioning of the content of the intervening shot.

The shot, then, is seen as the basic indicator of visual content. It contains all the visual data of the frame plus the potential for movement and sound; and it endures. A great part of what one can say about the film language is organized under the heading of "the shot."

It is sometimes convenient, and always dangerous, to speak of the syntax of the film in terms of the formal aspects of the other arts, usually literature.[8] Thinking this way briefly, the shot would be the communicative opposite number of the paragraph, although the content of the paragraph is distributed linearly and its elements are met one at a time, whereas the content of the shot is available all at once, as it were, and its order of "reading" is dependent on the glance of the viewer

[8] Indeed, the most superficial book in our field does just this.

(although certain compositional and narrative arrangements will guide and predict this to a degree). But if the shot is a paragraph, containing as it does literally hundreds of concise simple sentences (The book is on the table. The man is hungry. Night is falling. The room is shabby.), then one must understand this to be a paragraph from a Balzac who writes with the precision of a Flaubert and uses the sentence structure of an uninhibited Faulkner.[9]

Most of the visual content indicators reside within the shot (lighting, angle, decor, movement, etc.). But because the formal aspects of the shot control and, to some extent, create content, the shot is more than the vessel that contains content. It is even more than the elemental grammatical unit that supports content structure. The shot is also an indicator of content in itself. Quite independently of subject matter, although operating adjectivally to it, the shot possesses the qualifiers of field size and duration.

FIELD SIZE

Field size may be defined as the area within the frame. Technically, field size is spoken of as though all subjects were the same size and as though the frame area were a matter of the distance between the camera and the subject. (And indeed, this last was true very early in the history of film when a variety of lenses was not available.) Hence, the shots are conventionally described as: Long, Mid-long (or Medium-Long), Mid, Mid-close-up, and Close-up (usually indicated: LS, MLS, MS, MCU, and CU respectively.) Because not all subjects are the same size, and because lenses are interchangeable, these labels are

[9] If one felt impelled to compare the film syntax to the verbal one, it might be better to look at modes, rather than structures. For instance, an interesting case could be made for similarities between the shot and the haiku.

rather meaningless today. It is not true that a shot of a sky-scraper that fills the screen is more of a long shot than would be a shot of a beer bottle that also filled the screen. Field size is not a matter of the size of the object photographed, nor is it a matter of the distance from the camera to the subject. Field sizes must be labeled in terms of the kinds of content trans-ferred through exposure to the shot. Along these lines, the fol-lowing descriptions of field size are offered:

The Long Shot—a shot whose function is to indicate the en-vironment in which a passage takes place. Therefore, a shot of a beach is a long shot if the sequence in which it appears is some kind of dramatic exchange between two people sitting in the sand. The same shot is a mid-shot if the sequence is a description of an island in which the beach is an element.

The Mid-long Shot—a shot that accents the environment of a passage, but that also puts the partakers of the environment into their surroundings. Therefore, a shot of a beach with two people sitting in the sand is a mid-long shot, if the passage subsequently deals with the couple.

The Mid-Shot—the standard photography of all of the sub-ject, or of all of the subject needed to indicate the subject and "all-ness." In a passage dealing with an interrelation between two characters, the shot grouping the two is a mid-shot. If, how-ever, the passage concentrates on one of the two characters, the same shot is a mid-long shot.

In a passage dealing with New York City, the Empire State Building is less than a mid-shot, despite the large surface area covered by the field. In a passage dealing with alcoholism—a content that cannot be photographed directly, as can a building, but that must be constructed out of its physical surroundings and effects—a shot of a bottle is a mid-shot because it is all of one of the photographable elements out of which the abstract of alcoholism is created.

Although the mid-shot concentrates on the subject of the passage or on an element that, combined with others, creates an

abstract subject, some identification of environment is in-
eluctable, if for no other reason than the difference between the
shape of the subject and the shape of the frame. Therefore,
the mid-shot is always the subject seen with minor environ-
mental modifiers.

The Mid-Close-Up—a whole subject or spatial unit that is
less than the subject of the passage. Therefore, in a passage
concerning a couple on a beach, all of one person (or all of that
person necessary to establish him) is a mid-close-up. If, however,
the passage concerns one person of the couple, that person's
hands or face is the area of a mid-close-up. The environment
of the subject of a mid-close-up is seldom created within the
boundaries of the frame. On the contrary, the mid-close-up
typically unites with other shots to create the environment for
the passage. But because of differences in shape between the
subject and the frame, some modest indicators of environment
will usually appear in the shot.[10]

The Close-Up—less than that which experience would call
a whole. A window of the Empire State Building is a close-up,
if the subject of the passage is New York City, because normal
experience could not identify a window with a city. If the sub-
ject of the passage is the Empire State Building, the window is
a mid-close-up, because it is palpably a whole component of the
building. If the subject had been "windows," the same shot
would have been a mid-shot. Again, the field-area label is rela-
tive to the subject of the passage.

In summary, the field area is not determined by the distance
from the camera to the subject, nor by the length of the lens
used, nor by the surface area covered in the shot; it is deter-

[10] The content value of the incidental background detail appearing around
the edges of the subject in a mid-shot and a mid-close-up is the function of
many things, not the least of which is focus. The environment of the mid-shot
will have greater impact on the viewer because the environmental surroundings
of the mid-close-up may not always be in sufficiently sharp focus. This difference
is an effect of depth of field, which will be dealt with in a later section.

mined by the nature of the subject and the intrashot status of the given shot. Using the instance of the couple on the beach, and assuming that the subject of the passage is some interrelation between the two, the field-size indications should be: LS = a beach; MLS = a beach, with a couple on it; MS = the couple, on a beach; MCU = a person, one of a couple; and CU = a part of a person.[11]

FACT AND ATTITUDE

Any discussion of field area leads the film maker and the analyst to new considerations of the basic language of the film. After all analyses have been concluded, it remains that there are two large classes of content in any film or, for that matter, in any communication: facts and attitudes.

By "facts" we mean those aspects of the film message that can be given a noun label, even outside the context of the film, and without reference to the subjective reading of the film viewer. There are simple, photographable facts such as man, bottle, window, and tree. There are also complex facts that cannot be photographed directly such as marriage, urbanization, and economic depression. We may think of these as collective nouns that are created through an amassment of simple facts cemented together through story line and juxtaposition.

By "attitude" we mean those aspects of the film message that cannot be photographed or recorded directly, and that exist only when the content of the film has filtered through the subjective reading of the film viewer. Good and bad, love, worth, and emotional depression are attitudes.

The long shot is a more fertile carrier of fact than the close shot. Beaches, people, automobiles, and such elements of visual

[11] The special instances of field changes within the shot, as in the zoom or the crane shot, will be covered in the section dealing with camera movement.

fact abound in it. Also, because its emotional potential is limited, the intellectual potential is increased, freeing the viewer to regard facts coolly. Conversely, the close shot is the better carrier of attitude. Love, hate, desire, and despair are most economically and effectively transferred through the close-up, partially because of the emotional potential mentioned before, partially because the close shot excludes extraneous and distracting fact. Obviously, this very exclusion sharply limits the value of the close shot as a carrier of fact, just as the emotional insulation of distance limits the long shot's value as a carrier of attitude. In both cases, we are speaking without consideration of montage and the moving camera, both of which will be taken up later, and both of which can alter these normal capacities for content transfer.

These native and mechanical characteristics of content transfer based on the field size account for the film's conventional procedure of moving in on an action, from the long shot, to the mid-shot, to the close-up. They also account for the need for an occasional establishing (more distant) shot in a passage of rather close shots. Reinforcing these native characteristics is the truth that "meaning" depends more upon context than upon abstract properties of the symbols we call content.

DURATION

Simply, duration is the period of time the shot persists. More exactly, duration is the period of time the shot *seems* to persist. To clarify this distinction we refer to a principle in theater that all of the better directors instinctively adhere to: A scene is not "long" or "short" because of the number of minutes it lasts; it is long or short because of the felt length of each of those minutes. Duration, at least from the point of view of its effect on the audience member, is relative to the time necessary for him to come to a feeling that he has satisfactorily related to

the content of the shot. In theory, at that instant of satisfaction, he would have no sense of duration: no feeling that the shot was "long" or "short." The audience member's sensation that a shot is long or short results from his having or not having finished with the content. Obviously, a given shot might be long for one viewer, short for another. And these variances in individual reactions are among the difficulties met by the artist who deals with a mass audience.

Recently, we conducted some experiments on the relation of duration to the transfer of fact and attitude. Shots of various field sizes were shown to audience members for various lengths of time under reasonably controlled conditions. For the sake of testing (although we had reason to believe that this was not the case) it was proposed that the content transfer should vary with duration of exposure to the shot. That is to say, if the viewer reported six facts from a given shot after ten seconds of exposure, one might imagine that he would report more—although probably not twelve—in result of twenty seconds of exposure.

This did not prove to be the case at all. Indeed, once the duration of the shot was beyond a point of comfortable recognition and cognition, its prolonged duration on the screen seemed to have little to do with the transfer of content from the film. More content was reported after prolonged exposure, but this extra content did not come from the film; it came from the viewer's experience, memory, or imagination.

In the case of the longer shots (field sizes), there was no significant difference between the number of facts reported by viewers who were exposed to the shot for long periods and those reported by people who saw the shot for shorter durations. But many more attitudinal statements were made by those who had viewed the shot longer.

The opposite effect was observed in the case of the closer shot; no difference was reported in attitude as a result of dura-

tion, but a real difference in the number of facts did occur—the longer duration producing the greater report of fact.

The peculiarity of the reports resulting from long exposure was that the additional fact or attitude was not related directly to the visual message of the film. The attitudes reported in the instance of long exposure to the wider shot were typically "I-centered" reflections of past experiences alien to (although possibly triggered by) the substance of the shot. And the facts reported from the close-ups were usually made of whole cloth—remarkable instances of elements being reported as seen that did not really appear within the frame.

We found better things to do with our time than to attempt to account scientifically for these results—which task we donate to some future PhD candidate who doesn't care to make films and who has a way with IBM cards. But for our own purposes we suggested that we might have been experiencing the effects of a perceptual–psychic phenomenon that, for convenience, we labeled "centripetal decay."

CENTRIPETAL DECAY[12]

To understand the process, one must hold the mid-shot to be a constant, capable of transferring a mean ratio of fact and attitude (about 3 to 1, as our little tests showed). From this center, one moves out toward the fact-loaded long shot in one direction, and toward the attitude-loaded close-up in the other. As a shot endures on the screen beyond the point of comfortable cognition, the longer shot collects more attitudes, and the closer shot collects more facts. Thus, from the content transfer point of view, they tend to operate more like mid-shots as they en-

[12] Please keep in mind that this entire concept is only conjecture.

dure. In other words, they tend to fall inward toward the center of a continuum of field sizes.

Centripetal decay seems to operate on at least two levels: the perceptual and the interactive.

On the perceptual level, the audience member seems to view the long shot by first scanning the frame for information. As the shot continues in time, the viewer tends to pick out some element within the frame and to concentrate his attention on it, the rest of the data in the frame operating as the environment for the selected element. In short, the viewer manipulates his attention and focus in such a way as to treat the shot as though it were a mid-shot (the photography of a given subject with some elements of environment, as the reader may recall).

Beyond central position on the screen, elements of composition, contrast, and eye-guiding through editing, the selection of the subject by the viewer seems to be random—random, that is, in terms of the sequence in which the shot appears. It is possible that the choice is determined by dispositions and associations operating within the viewer's extrafilmic experience, but this is obviously a matter beyond the control of the film maker.

In the case of the close-up, the viewer seems to scan the image for a time (a shorter period than with the long shot), then to concentrate his attention on some minute object within the frame—one eye, for instance, or an eyebrow. As he does this, the rest of the face becomes an environment for the object of concentration, and the shot again operates like a mid-shot.

It should be mentioned here that most of the subjects of the experiment reported a fairly rapid and random change in the selection of objects of concentration. In a way of speaking, the close-up that endures longer than is required for transfer of the attitudinal message seems to be broken up into a series of midshots of factual content. Also, the viewer seems to experience some kind of discomfort in the case of the prolonged close-up of

the human face—more than any other object—that hastens not only the moment of comfortable satisfaction with the shot but also the subsequent alterations from one aspect to another, once he starts to fragment the image.

Centripetal decay also seems to operate on an interactive level, and again there is a tendency for the viewer to convert the shot into a mid-shot or a series of mid-shots, from the point of view of fact–attitude balance. Again, the effect sets in after the shot has endured past a certain threshold of satisfaction, and again this duration differs from viewer to viewer. Once this line is crossed, new content is introduced in result of an inter-action between the film content and some experiential content suggested, awakened, or triggered by the content of the film—but not necessarily related to it in more than a genetic way.

In general, it can be said that overlong duration of long or close shots alters their peculiar content qualities in the direction of the center of a continuum of possible field sizes (hence, "centripetal decay") and makes them operate rather like mid-shots, from a linguistic point of view.

More, and often deeply effective, content is generated by the shot that endures long on the screen, but the film maker cannot control the nature of that content.[13]

In summary, we have seen that the shot is the basic content element of the film language. Beyond the specific message of any given shot, there are formal content implications that can modify, enhance, or undermine the intent of the film maker. These have been described as field size and duration.

[13] "Classic" Warhols, with their motionless insistence on audience decoding and their *reductio ad absurdum* of the principle of duration, may be profitably studied as experiments in these phenomena.

The Sequence

The sequence is a series of shots related in locale, cast, motive, or point of view. Roughly, its literary counterpart would be the chapter, being more than the shot (paragraph) and less than the film (book). The typical punctuating device for the sequence used to be the fade-out—which will be discussed in the section on editorial devices—but in today's faster moving, less conducted films it is often the "forced logic cut" (also to be discussed later).

The sequence is the smallest level of the film form that possesses that Aristotelian wholeness needed before one can dare to make meaningful statements and criticisms. The shot does not have this quality because both the film maker and the audience member view the shot in terms of the shots that have conditioned perception previously and in terms of the shots to come that will qualify the visual statement. Like any other basic element of a language, the shot is, at best, incomplete, and, at worst, meaningless when it is considered out of context. At the end of a sequence, however, the analyst or critic may sit back (just as the audience member is allowed to do through the visual relief of the fade-out) and consider what has gone before as a whole, interrelated, if extremely complicated, message. Any film must be analyzed in terms of its sequences if qualitative insights are to be useful, although clarifying and supporting statements usually come from reference to the content and form of the individual shots—just as a film is designed and shot and edited in terms of the sequence and the feelings it is meant to evoke.

This is not to imply that the sequence is whole in the sense that it is terminal. A given sequence might require the audience member to have a considerable amount of data beforehand if

he is to understand it. Another sequence might point strongly onward for its resolution. If this were not the case, indeed, the film maker would be guilty of soporific redundancy and low economy of information transfer (as in most teaching films). The sequence is whole in the sense that it is a whole beginning, a whole middle, or a whole end. (Reference here to Aristotle's cautious, prolix description in *Poetics,* Section VII.) At the end of a good sequence the audience member feels satisfied that the action has been advanced as far as these characters in this locale at this time can profitably advance it. Should one choose the dangerous suggestion of similarities between film form and Greek drama, the sequence would relate most closely to the stasimon; the shot to the strophe or epode; the film to the play; and the cycle (in the sense of the "prison cycle" of the American cinema of the 1930's) to the trilogy.

Editing Devices

Editing devices, the means by which one shot is connected to another and one sequence to another, constitute visual content not so much in that they create or embody it, but rather in that they clarify, signify, and modify the content created within the shot or sequence. These devices are the punctuating marks of the film language; they serve to link and separate elements of content.

It should be understood beforehand that no part of the film language is static and immutable. In the following pages the typical implications of the various editorial devices will be described, but always with the understanding that any given film can produce its own valid and temporary meanings for any of the devices. When a film maker chooses to use a device in a way not common to the body of film literature, he must expect some early confusion—some early loss of meaning and feelings

of comfort on the part of the audience member. But so elastic is the medium that, before long, the viewer will come to accept the device in the film maker's terms.

Shots or sequences may be joined or separated by the cut, the dissolve, the wipe, or the fade. Less common, and less reliable connectors are the wash and focus-out/focus-in.

THE CUT

The cut is an instantaneous exchange of one shot for another. It is the most common of filmic punctuating devices and is fairly neutral in content significance, but certain of its perceptual implications have to be considered.

A cut at the end of a shot projects its content forward. One does not "cut from" nearly so much as one "cuts to." The cut causes the second shot to be seen in terms of the first (simultaneously, in fact, for an instant, because the exchange occurs in one twenty-fourth of a second and the average image retention on the retina is about one-tenth of a second). This forward implication operates in terms of both time and logic. The film viewer reads the cut as both "then" and "therefore." This skill must be learned; the film illiterate is incapable of discovering much of a relation between one shot and the next, just as the verbal illiterate would make rather little out of commas and colons. In the film, one rather important difference between "story" (a series of events related through continuity in time) and "plot" (a series of events related in cause and effect) is that in the plotted film, the cut reads largely "therefore," whereas in the history or biography, it reads largely "then."

Although the cut is rather neutral of content—being the natural and least biased punctuation for the linkage of one shot to another—there is one circumstance when the cut takes on content significance. The countercut (or switchback) sequence in which action in one locale is interwoven with action in

another is most fruitfully seen as two sequences shuffled together, as one might shuffle together two decks of cards with different back designs. In this instance, the implication of the cut is either "meanwhile" or "however."

Historically, it has been uncommon for the shot following a cut to be in a different locale, or to include different characters, or to involve a leap of time. However, this idiomatic limitation of the cut has been attacked often and successfully by film makers who have cut from place to place and even—in the extreme freedom of the low-budget, personal-expression film (the New Wave, or neorealism)—jump cut within a length of camera footage.

In these cases, the cut operates like a dissolve or a fade-in/fade-out used to operate. More times than not it will have the qualities of the "forced logic cut." To explain this forcing: If we cut from a young man in his room to the same young man walking down a city street, the audience member is forced to believe that a period of time has passed—his sense of logic and his personal experience allowing no alternatives. The same would be true of cuts involving changes of costume, the time of day, and—in the most subtle of the forced logic group—of changes in attitude and energy.

The Dissolve

Perceptually, the dissolve (lap-dissolve) is an editorial device that permits the second shot to emerge through the first and replace it on the screen. Generally, the device serves more to separate than to link, permitting as it does a major change in locale, cast, motive, or point of view. For the audience member the dissolve signals the end of a satisfactory, if not total, communicative event and a juncture at which the preceding group of shots may be examined as a whole.

Although this terminal function is the most common use of

the dissolve, it is not the only one. Of all editorial devices, the dissolve possesses the greatest potential for permitting the content of one shot to influence the audience member's attitude toward the following shot. This is true because the second shot is literally seen simultaneously with the first for the duration of the dissolve. (The length of the dissolve is a variable and controllable factor for the director or, more often, the editor.)

Finally, in the case of substantive montage (which will be discussed later, but which is the creation of one concept out of a group of contributing images), the dissolve is often used to link up the pattern of "building block" images kaleidoscopically, thus insisting that the montage be seen and considered as a whole.[14]

The Wipe

The linguistic qualities of the wipe hold true for all optical matte operations, such as the divided screen.

The wipe is a highly formal and palpably mechanical device. In its simplest form, the wipe appears to be a line traveling across the screen, devouring the old shot as it goes, and leaving the new shot in its wake. Variants of the wipe include the explosion wipe (bursting from the center outward), the spiral (or jelly-roll) wipe, diagonal wipes, and the barn-door wipe (beginning in the center of the screen and advancing toward both sides at the same time), along with any number of shapes and patterns for the advancing line.

We have said that the wipe is an obvious and formal mechanical device. All of the other editorial devices have some recognizable parallel in the visual and emotional experience of the audience member. The cut, for example, is not unlike a

[14] Unfortunately, the dissolve finds wide use in the hands of lazy or incompetent editors who use it, against the grain of its linguistic implications, to join shots they have failed to match in action or eye-guide.

blink. Indeed, when a person looks from one object to another, he does not normally "pan across," he blinks as he changes field and focus, producing an effect very like the cut. This fact is one of the reasons the subjective camera role-playing the actor is never visually convincing, unless we are seeking a dreamlike state. The viewer can find parallels for the dissolve in memory, in dream, and in the act of concentrating on one matter while in some alien set of surroundings.[15] And the fade corresponds to sleep.

But the wipe is a purely filmic device that cannot be expected to flow unnoticed before the viewer's eyes. It threatens the illusion of ongoing, empathetic realism; therefore, means must be sought for reducing the effects of its mechanical intrusion.[16] One way to lessen the obviousness of the device is by disguising the motion of the wipe line under some concurrent motion within the frame, such as having the wipe line follow the motion of a truck crossing the screen. The artificiality of the wipe can be further reduced by carefully matching the composition and lighting between the two shots.

The reader has a right to wonder why a film maker would use so clumsy a device. Like the dissolve, the wipe usually signals a change in time, locale, motive, or characters. But the device is not so frequently used as is the dissolve, and therefore its meaning has not become so firmly fixed in the passive film vocabulary of the audience member. This frees the film maker to give the wipe an editorial meaning of his own, granting always that he is willing to risk some obscurity at the beginning

[15] We have spoken of the dissolve as a terminal device, which it usually is. It can also be used as a connective between unlike things where it repeats the visual experience we have all had of "dissolving" in and out between the world of our surroundings and that of, for instance, a book we are reading.

[16] Unless, of course, you want to create a feeling of formal and nonreal structure. Kurosawa, in his *jidai gekki* films, combines operatic acting style and structured camera movement with many wipes, and produces a formal and brilliantly otherworldly style. Kurosawa accents the "scenic" or formally theatrical aspects of his films through the wipe, which he often uses as an "act curtain."

of his film while he is making his personal use of the wipe idiomatic to this particular film.[17]

Because of the conscious and intellectual activity awakened in the viewer by the mechanical appearance of the wipe, it is probable that factual data are accented through it, while attitudinal data are more constricted.

In the case of the substantive montage linked by means of wipes (an effect identified with silent film, but currently fashionable again among film makers), the informational bias of the wipe is somewhat vitiated because of the considerable conditioning effect that results from the two shots being viewed simultaneously. This simultaneous viewing, however, is not so effective in the wipe as it is in the dissolve. The viewer is forced to look at either one shot or the other—one side of the screen or the other—and he is not really viewing them simultaneously as he is in the dissolve, where they are in one field.

THE FADE

Although not in very high fashion just now, the fade is a senior resolving device. In the standard fade, the screen becomes dark, then black (void of data), then a new shot emerges through the blackness. The fade, obviously, has no linking effect at all; it is a major separating device. The fade operates as a point of division, the end of a movement, the erasure of the blackboard, and an opportunity to create anew on the *tabula rasa*. It is at the moment of the fade that the audience pauses and evaluates what has gone before.

[17] A classic case of the wipe used in a special way by the director occurs in Carne's QUAI DES BRUMES. Twice the barn-door wipe is used to bring us from the exterior of a building to the interior, lending the device a "within" quality. Then, at a moment when the hero Jean (Gabin) is thinking about the heroine, a close-up of him is barn-doored apart revealing her. We have a feeling of "within" (or thinking about), but the director was free to go on with the story, because there was no necessary implication of previous action or remembered events.

Emotionally, the fade offers a moment of relief from tension. It permits the film maker to begin on a new climax structure —a structure that will naturally tend to build higher than the preceding one because some level of tension must necessarily carry over residually from the preceding sequence to form a platform from which the new climax begins.

It is important for the film maker to realize that after the fade the audience does not approach the new sequence altogether fresh and empty of attitudes. Indeed, if they did, a film would be nothing more than a series of one-reelers. Actually, the viewer greets the new sequence in terms of a certain lingering conditioning created by the content of the preceding sequences. Still, the only mechanical bridge between the content of one sequence and the next is sound; the primary channel of filmic communication—the visual—is broken.

FADES TO WHITE AND COLOR

In some experimental films and recently in the undertow of the New Wave, the fade to white has been used as a terminal device.[18] As the fade to black might be described as the gradual underexposure of the film until all data dissolve crepuscularly into darkness, so the fade to white may be viewed as a steady overexposure of the film until all data are illuminated too brightly to be seen. Perceptually, the fade to white seems to allow the audience member to see through the subject and beyond into an empty, blinding whiteness. The fade to white has the effect of holding the audience member's attention on the screen, which is brilliantly lit, and of giving him no time for relection or relaxation of tension. At the same time, it has the Dadaistic effect of erasing content totally and allowing no residual image to penetrate into the forthcoming sequence.

[18] The device gained currency with L'ANNEE DERNIERE A MARIENBAD; Resnais (1961).

This last requires a little explanation. In the fade to black, the principal subject (typically the most brightly lit) is the last visual element to disappear and, therefore, is most likely to carry through the visual pause to impress its residual conditioning onto the audience member and the coming sequence. In the fade to white, the principal subject is the first thing to disappear and is, therefore, unlikely to bridge the memory to the coming sequence.

Fades to color seem to operate about halfway between fades to black and fades to white, linguistically speaking. The device is too new and remains too much on the edge of the film language to be dealt with authoritatively.[19]

If the sections dealing with the wipe and the fade to white seem to criticize the use of these effects, this was not the intention. Some stress has been placed on the obvious and mechanical nature of the wipe; and the inability of the fade to white to carry much in the way of ongoing conditioning was pointed out. But this is not to say that these devices are bad. In fact, the only "good" or "bad" of an element of the film language resides in its effectiveness and appropriateness. It is perfectly possible to imagine, in a fantasy or a film version of a formal drama, that a film maker might want his mechanics to be obvious. And in a film that concentrates on emotion and tension over logical development of idea and character, a device like the fade to white might be most effective. The great danger of these and similar mechanical devices is that they are flashy and tend to attract the makers of experimental and message films. Often the young film makers get away with these pyrotechnical effects, more or less as the emperor got away with going about nude, because their audiences are no more sophisticated than they. Such surface devices give an unfortunate escape to the path of least effort and cheapest applause to

[19] We speak here of fades to red or blue, as in LE BONHEUR and FAHRENHEIT 451.

potentially creative film makers who, if they were required to learn their trade, might become valuable to the film art.

THE SWISH PAN

This device has the visual effect of a high-speed blurred pan from one shot to the next. Like the fade and the dissolve, it is a major connecting device. Like the fade to white, it accomplishes its bridging on one sequence to another without allowing the audience member's attention to leave the screen. Like the wipe it is a most palpable and mechanical device—one that reminds the audience member that he is seeing a movie, unless it is covered under a passage of rapidly moving data.

Unlike these others, the swish pan has an added implication of action and excitement. Generally, without the reinforcement of the forced logic cut, the swish pan is best equipped to change locale without a very considerable advance in time. It tends to say, "elsewhere, the next moment."

THE WASH, THE FOCUS-OUT/FOCUS-IN, AND PHOTOGRAPHED EFFECTS

These are the more common of a little constellation of rare, rather artificial editorial devices that may be used to link or separate shots. Most of these are best reserved for very special functions or used under titles or narration where their native vagueness can be reduced by accompanying information. Like the wipe, but to an even greater extent, they draw attention to themselves.

The wash (the exchange of shots under a ripple effect) has been used often enough in the flashback circumstance so that most film literates can accept its code, but hardly without noticing its appearance and feeling that the device is now out-

moded. It would, however, be difficult to use the device for any purpose other than the flashback, and even then it is conventionally supported by either artificial sound or by directing narration (both terms to be discussed later).

The focus-out/focus-in is usually used with the subjective camera and typically indicates semiconsciousness or abnormal states. It has its counterpart in perceptual behavior during similar states and would be a valuable element of editorial content if it were used more often. As it is, the device lies at the rim of habituation for film literates and is not so "readable" as the more common transitional devices.

Photographed transitional effects operate rather like dissolves, or washes, or focus-out/focus-ins, and typically they employ one of these connectors to smooth out their photographed elements. An example of the photographed effect would be a transition from smoke at the end of one shot to steam at the beginning of another. A similar effect can be produced by a match from glaring light to glaring light, from rushing traffic to rushing traffic, etc. If handled skillfully, the device will propel the audience member into the second shot without his knowledge, until the effect of forced logic sets in.

Angle

As a carrier of content, camera angle is largely dispositional. Angle serves more to modify content than to create it. The basic visual data remain fairly constant as the angle of photography is changed, but, in a variety of ways, angle alters the terms under which the subject matter is to be viewed. Primarily, a change of angle alters the composition of the shot, and, thereby, the environment in which the principal subject is to be seen. This involves certain inclusions and exclusions of

surrounding and qualifying matter. Beyond this, angle may be regarded as subjective, attitudinal, or intensifying.

When one speaks of changes in angle, one is implying the existence of a normal or neutral angle from which this change is being made. It is possible that, through repeated use, a film maker could create his own neutral angle in a given film, but —except in the case of the subjective camera—the natural angle is usually found along the central axes of the subject. Hence, a natural angle of a bottle would be taken from the height of the center of the bottle. Similarly, a natural angle of a man is taken, not from eye level, but from a little below eye level, nearer to the center of the body.[20] This is not to say that a natural angle of a large building has to be taken from a camera position some fifty yards up in the air. Buildings, if shown in entirety, are normally shot from a considerable distance, and, because angle decreases as distance increases, an eye-level shot at great distance will have much the same angle as would a closer shot taken from fifty yards in the air. If, however, the shot of the building were taken from rather close, and the camera held at eye level, the shot's angle could no longer be said to be natural. So much would the angle have increased that the shot would be either subjective or indicative of a considerable domination of the building over the events of the sequence.

Subjective angle is obtained by photographing the subjects as though they were seen through the eyes of a character. In a way of speaking, the subjective camera is, or represents, a character, for the duration of the shot. Now, we shall find that "up" angles and "down" angles have a certain content implication. The subjective camera, however, tends to lessen these implications because the audience member becomes aware that the

[20] This, oddly, despite the fact that normal visual experience of another person is from eye level.

angle is determined by the height of the character and not by the dominant or recessive nature of the subject. Despite this, a certain overtone of "up" or "down" angle will cling to the whole sequence. After all, the camera is a character, and tall people tend to dominate, whereas children or small people tend to be dominated.

Attitudinal angle is the principal content virtue of camera angle. By the alternation of angle along the horizontal axis, the viewer can be made to look down or to look up at the subject. The effects possible range over a full continuum from the dominance of the subject to its relative insignification. The interesting thing about attitudinal angle is that it tells the viewer not what he is to feel about the subject being photographed, but what the subject feels or is, in terms of other subjects and events.

There is an unavoidable additional effect to attitudinal angle that has to do with the inclusion and exclusion of data. By the nature of rooms and outdoor locations, the "up" angle tends to set the subject against skys, clouds, clear walls, and other backgrounds that ennoble and isolate him. "Down" angles, on the other hand, will include floors, dirt, and other fragments of more earthy existence that call to mind utter dejection and tend to further reduce the dominance of the character.

Information within the shot may be intensified by the use of odd, uncommon, or surprising angles for the purpose of accenting content by means of contrast. Obviously, this intensification of content by departing from common angles is a function of the particular film or sequence, since what would constitute a "normal" angle (from which to depart) is in the hands of the director or the director of photography.

The practice of showing action from angles not common to human experience is ancient in art (the Chinese have done it from the earliest times, and the device has been popular in Western art since Correggio), and it has, through continual use,

become a common and quite readable element of the film language.

The various effects of angle have been isolated here for ease of discussion. In practice, angle is usually selected because it "feels right," and any given shot from any given angle may partake of the content implications of several or all of these described effects. There is also the matter of change of angle during the shot (an effect of the moving camera), which will be treated in the section on camera movement.

Lighting

On the face of it, lighting conveys certain elements of factual content such as day, night, interior, or sunshine. Local instruments (the seeming sources of light) add certain data concerning the nature of the locale: expensive lamp, lone naked light bulb, shaft of light from a gas lamp, etc. In addition, these matters of locale extend to give indications of era, of socioeconomic status, of the taste and background of the characters.

But beyond and more important than these matters of time and locale, lighting can make prominent attitudinal statements of mood. Take, for instance, night: There are gay night fetes with strings of garden lanterns, and there are nights of London fog. Lighting, as much as decor, creates these differences of mood.

Lighting can also be the most significant element of contrast between two shots of similar composition and subject.

One of the most important content values of lighting is its ability to point up or to deny. Any subject can be singled out for attention through its lighting; elements of environmental data can be accented or attenuated through the use and positioning of light.

General lighting (the overall illumination of the set) tends to

widen the frame and to insist on the importance of environ-
ment acting on the character or event under consideration.
Specific and pointed light, on the other hand, tends to tighten
the frame and to make the subject relatively independent of
his environment (except, of course, if that environment is
night).

Just as pigment and carrier in painting are the basic mechan-
ical materials for expression in that language, so for reasons
basic to the science of photography, light is the *sine qua non*
of film making. Since there has to be some, and that some has
to be under control, the film maker might as well make it work
for him at a higher level than merely exposing the film well.[21]

Color

To begin with, color is beautiful, and it is spectacular, and
the audience seems to prefer it in general; and that is probably
why we use it.

But there are linguistic qualities to color too.

Despite the fact that learned men have ascribed certain emo-
tional values to certain colors (a kind of unfortunate collision
between Seurat and educational psychology), it is most danger-
ous for the film maker to rely on these postulations for effect.
For one thing, color is relative. Like everything else in the

[21] Probably the reader shares my view about the inadequacy of this section
on lighting, but there's little I can do about it. Very few film makers can talk
cogently about light; I do not claim to be the exception. This is one reason
why a good director of photography will put the last touches to his lighting
himself; it is difficult to describe lighting in terms of each nuance that separates
good from merely adequate lighting. Often it is simply a matter of moving an
instrument ever so slightly to get the proper effect.

In the section on image characteristics, exposure, contrast, and other light–
film–lens effects, which most filmgoers view as effects of lighting alone, will be
discussed.

medium, it exists in time as well as in space; so the film maker must know, not only that a given thing is red, but just how red it is. A red of middle saturation is not very red at all, if it follows compositions dominated by highly saturated reds. By the same token, any red is very red indeed after a green-blue passage. This concept is not strange to painters who are used to seeing colors in spatial relation to other colors, but few have experience in evaluating colors in temporal relations. Any average eye can see the effect of a red *next* to a green, but it takes time and skill to see the value of a red *after* a green.

Although one may doubt the validity of attaching concrete values to colors in the abstract, one recognizes that the film maker can make telling statements by the use of symbolic color, provided that he, like Antonioni, produces the symbols within the film that uses them. Rather in the mode of a leitmotif, a color used repeatedly with one character or one emotional state will take on the message values of that character or that state, even when it appears elsewhere in the structure of the film. A great deal of planning is necessary to make a color symbol work effectively, and even then it is not likely (or desirable) that the audience member responds by recognizing the origins of the feelings and attitudes he receives from the film. The effects are all the more potent when they are injected, as it were, intravenously.

Beyond its symbolic use, there are three other effects of color in the film language that deserve consideration: color linkages, color voiding, and the special problems of color and realism.

There is a fine line between color symbol and color linkage. In the case of the symbol, the color stands for (or "means") something. This may be more than a simple case of red equaling passion; it may be a broader and more subtle use of the palette. In Antonioni's THE RED DESERT, for instance, the cold and hard-edged cosmos of machine and things masculine is represented by pure and fully saturated color, while the vague

and feminine world of feelings is represented in mixed earth colors and pastels.[22]

Color linkage is the merger (or separation) of characters, events, or attitudes through the use of color. A given character is in or out of harmony with his surroundings on the basis of color. Two characters blend or complement through color. Two characters may be equally well blended with their environments, but clash in relation to one another. Costuming, of course, is the fundamental carrier of character color, just as decor and filtering give the film maker control over the local color of the setting.

Color voiding is the purposeful reservation of a color or a range of colors from the palette of a given shot or sequence for the purpose of intensifying the moment, character, or attitude identified with that color when at last it appears. Obviously, color voiding operates on the principle of relative color—either in time or in space. In a sequence that is all greens and blues, the first instance of a red will command the audience member's attention and satisfy his feelings for balance, regardless of other qualities the red thing or event may have. Color voiding as a tool of the film language has been used infrequently, probably because of the difficulties of control involved. For this reason, one might expect its first appearance in the highly controlled Japanese film. We have the example of JIGOKUMON (THE GATE OF HELL) in which Kinugasa Teinosuke uses the device brilliantly, all the while protecting himself from the inherent problem of obviousness by the gentle pastels of the film.

Now that film makers are giving more and more attention to color as something more than decoration and audience attrac-

[22] In this film we find color applied to interiors in such a way that the audience member cannot possibly miss its implications. Great and unrealistic blotches of pure color are splashed about the factory with little mind to the appropriateness or likelihood of its existence. The effect holds nevertheless, despite Antonioni's aesthetic preference for the mace over the rapier.

tion, one can look forward to greater use of the linguistic potentials of color voiding, I suspect.[23]

The problems of color and realism now being discussed by young film makers attest to the organic and changing nature of the film language. The issue revolves around the question whether color films are more or less realistic than black and white ones. Despite the fact that the audience member's quotidian visual experience is in color, one would have had to say, a few years ago, that realism was firmly linked up with the black and white film. If a friend reported that a film he had recently seen was most "realistic," almost everyone would have envisioned the film as a black and white. Color was for travel films, musicals, historical extravaganzas; black and white was for both the nitty and the gritty, the sociological film, the brutal street film. And perhaps there is nothing immutable and native in black and white that makes it more "real" than color, other than the total of our past film experience.[24]

As color became more common, less expensive, and "faster," it became possible to use the precious stock for films other than million-dollar musicals and spectacles, and the possibility of a color film holding its qualities of realism increased. To this day, however, it remains true that the "real" and earthy film is more likely to be shot in black and white, partially for financial reasons, partially because it is easier to use black and white stock on real locations with local light, partially also because, although there are color films dealing with real prob-

[23] The linguistic concepts of relative color, specific symbol, and color voiding have been dealt with here as separate entities, although of course they may all operate at one time. A good example of the combined effect of all three would be Godard's LE MEPRIS in which the symbol-identified reds and blues also operate in terms of relative color—clashing as near opposites—and color voiding —the reds rushing into the spectrum gap created by the blues.

[24] Some theorists have chosen to follow the Suzanne Langer line of thought that places the film form in the dream mode. Since most people, we are told, dream in black and white, they reason that the native—most dreamlike—therefor most "real" films are black and white. Maybe.

lems and people, there are no black and white musical comedies, and we are in the habit of associating color with the unreal.

At present, however, there is a clear trend among young film makers away from the capturing of surface naturalism and toward a more illusory content of inner realities, emotional states, and subjective reporting. And in these other manifestations of the real, color has been and will be a valuable tool.

Image Characteristics

This intentionally vague and elastic heading will comprise several linguistic elements in the film that operate rather similarly. They are: depth of field, focus, exposure, film stock qualities, and lens characteristics. Because the control of these factors (and often even the knowledge of their existence) is within the technical area of film making, they are little talked about by critics and analysts who, for the most part, are not film makers.

In Hollywood film making of the thirties and forties (as in Rome, Jointville, Tokyo, and all the other Hollywoods), there was a most limited use of these elements of the language. To be sure, focus variants were used for cosmetic purposes and deep fields of focus avoided control problems in the "sausage factory" quickies; but for the most part creative use of image characteristics was blocked by a neatly circumscribed kind of thinking that suggested the existence of an ideal exposure, any departure from which was "over" or "under," and therefore wrong. Focus too was "in" or "out"—right or wrong.

Although the makers of documentary and experimental films had always exercised the image characteristics of film (often because it was the only thing they could afford to manipulate), their work and discoveries hardly affected the main line of the

dramatic feature film, mostly because the men working in the dramatic film seldom met and certainly never exchanged ideas with the men in document and experiment. World War II changed all this. Documentary men and Hollywood types mingled ideas and approaches in the theatrical war films and in report and document films made to propagandize the war. Immediately after the war, and most evidently in Italy, films emerged that established the linguistic tools of image characteristic.

DEPTH OF FIELD

The depth of the field is the distance through which objects are in acceptable focus. More technically, it is the distance between the point nearest the camera lens and the point most distant from it—at a given focus, with a lens of a given focal length, at a given iris opening—at which objects are sufficiently sharp in focus that the audience member is prevented from recognizing that they are slightly blurred. (Theoretically, there is only one plane or slice of the cone in which objects are in truly brilliant focus.)

Through changes in the intensity of lighting, film stock, and through the use of lenses of different focal lengths, depth of field is adjustable. Therefore, it can be assumed that it is within the control of the film maker and can be read as a part of his communicative content.

Because the principal subject is usually in hard focus, depth of field really concerns surrounding or environmental data. The more shallow the field of focus, the more the viewer is driven to concentrate on the major subject of the shot, and the less he is allowed to view it in terms of other visual data within the frame. The opposite is true of the deep field.

Thus, the deeper the field, the more the shot and its action operate in terms of environment (the more like the long shot it is). The more shallow the field, the more the shot operates

in exclusion of elements of environment (the more like the close-up it is).

In terms of the attitudinal–factual view of content, the deeper the field, the more factual data is most likely accented by virtue of its mass. The more shallow the field, the more attitudinal data is accented by virtue of concentration.

At present we notice the heavy use of the shallow field particularly in films from France, because the French have a penchant for the long lens and because of their changeover to color (slower) stock. However, our own film makers are relying more and more on the shallow field for the purpose of accent and eye-guide. True, the deep field—quite aside from its information-loaded linguistic qualities—attracts the cameraman because of the relative ease of handling follow-focus problems within a shot. But the shallow field alone allows him the use of "focus-through" and eye-guiding.[25] One of the ways to be sure your audience member is looking where you want him to look is to deny him alternatives through focus. This is a more complicated matter than it would seem at first. Not only does specific eye-guide depend on a shallow field, it also requires care in actor blocking, furniture arrangement, and decor. The human eye is remarkably discrete in its focus. It can afford to be because it is also remarkably rapid in focus change. When we look at one object, not only are things in front and behind that object isolated by defocus, but things to the left and right are also out of focus. Not so with film. All of the visual data in the plane of the principal subject—to the left and right of it— are in equally brilliant focus and are, therefore, available for alternative examination. This loss of directional control can be compensated for by arrangement of set elements and by actors; care must be taken not to allow any two subjects to fall within one plane (or, if you prefer, forcing two of them to do so). This is rather difficult to do without destroying the seeming realism

[25] The focus-through will be dealt with in the next section.

of the set, but the ability to do it is one of the marks of the coming generation of set designers who will be prepared to contribute something more than "pretty" and "accurate" to the film language.

FOCUS

When the instruments of film making were less sophisticated (and more complicated), all the skill of an experienced and competent cameraman was required to produce images of acceptable focus quality. It is only natural that the objectives of focus were clear and simple at that time. An object was in focus, and therefore "good," if it looked more or less as it might in life, viewed by a man with good eyesight who was sober and who concentrated on the subject.

Even this limited view of the role of focus demanded a great deal of skill in following a subject in motion; also, focus was considered one of the determining factors (together with composition and lighting) in the selection of the principal subject within the frame. It is even true that focuses other than sharp and brilliant were used in cosmetic photography (gauze shots and all) and in subjective camerawork (man rendered unconscious by a blow or a drug, for instance).

In the last few years, however, film makers have built upon these early limited uses, and upon advances in film technology to make of focus an important tool in the creation of subjective and internal reality—modern film's most fecund field of exploitation. Focus is now used to abstract environments, isolate characters and events, reproduce emotional states, control the audience member's attitude toward a given scene, and as a subtle transitional device employing the focus-through.

Most of the newer effects work from the principle of soft focus. They place elements within the frame outside the depth of field, or on the rim of it, and blur them to some degree. At

times the principal subjects are totally dumped in focus, being only blurs moving through a focused environment (LE BONHEUR or A MAN AND A WOMAN, for instance). At other times the defocused field is allowed to disturb the audience member for an instant before a character steps into the frame to satisfy the eye (THE RED DESERT). In this last instance, firm control of depth of field allows focus to work rather like off-balance compositions of color-voiding work, in that it leaves the audience member in a condition of achieved satisfaction when the focus is justified by the arrival of the subject (just as a character can move in to satisfy a balance, or to fill the palette of a voided color frame).

These controlled techniques require that the field be fairly shallow, and this need goes hand in hand with the wider use of color film and longer lenses and non-studio lighting, all three of which tend to shallow the field, and all three of which are intrinsic elements of the newer film styles.

The shallow field also permits the focus-through—a change of focus that carries the viewer from some object clearly seen (usually in the foreground) to some new object previously out of focus. The most important linguistic element in a good focus-through is that the defocuses are so total as to blur the alternative subject beyond recognition. Something new in the frame—something that was always there, but unrecognizable—replaces the original subject of the shot while the first subject spreads, blurs, and softens, sometimes into translucence.

The device of the focus-through is linguistically similar to the dissolve. It has, however, two special implications. First, the data at the end of the shot were always present, although not recognized; and for some moments after the effect, the latent possibility of revelation within the frame (or, by extension, in the narrative) will affect the audience member. Second, unlike other editing devices, the focus-through places the implications of the second part of the shot upon the first. Usually, transitional devices tend to spread the implications of the first shot

upon the second, as one might expect in a temporal medium; but the viewer of the focus-through says, in effect: "That was there all of the time?" and he considers the first of the shot anew, now in terms of the following data.

Unfortunately, the focus-through is pretty and artistic, so its linguistic implications have been abused by sheer toying about with the viewer's eyes (as in ELVIRA MADAGAN and HEAT OF THE NIGHT).

These uses of the shallow field and controlled defocus to create illusion constitute only one side of the linguistic potential of focus. The other lies in the effects of abnormally brilliant focusing.

The lens is capable of isolating small segments of the visual experience that we typically pass over in daily life. By enlargement, framing, and focus, it is possible to present things that the viewer has often looked at, but has never seen. Because the lens is capable of focusing more sharply than the eye normally does, and because, in the case of the human body, it can focus more constantly than the eye dares to, it is capable of producing an unreal presentation of a real object. For example, shots of a woman's hair, newly combed and carefully lighted with grain patterns like walnut paneling, were unidentifiable as human hair until some movement of the head suddenly revealed the subject.

In the newer cinema of subjective and internal reality, brilliant focus on isolated everyday visual experiences will serve to give them a quality of twilight reality that will stimulate the viewer's imagination and free him from the restrictions of recorded experience.

EXPOSURE

Rather like focus, exposure was once thought of as correct or incorrect—as good or bad. Good exposure produced images

whose darks and lights repeated the normal visual experience of the audience member. Some experimental films obtained (or inadvertently ended up with) variant exposures (typically "over" or too bright) that lent them dreamlike qualities. And the mainstream of narrative feature films has always used controlled underexposure to produce night effects. But it is only in the last ten years or so that film makers have been viewing exposure as a valid tool for affecting content.

Because of the mechanical latitude of film (especially of black and white negative) it is possible to maintain realistic detail over a wide spectrum of exposures. Therefore, the surface realism of a scene can be maintained while the film maker manipulates exposures to create some overriding mood. Technically, this manipulation of exposure is a combination of several factors—lighting, f-stop setting, film stock, and laboratory procedures—but it is simpler to view it as thought it were a simple matter of overexposing or underexposing the film.

Film darkened by underexposure causes a crepuscular and foreboding overtone to permeate the scene, while it does not deny meaningful environmental detail, as would be the case when shooting with mottled or limited light. This happens because all elements within the frame are reduced equally in intensity. In general, except for day-for-night shooting, underexposure has yet to be explored and exercised by film makers.

Overexposure, however, has already become a popular tool in the language of modern films. Its effects range from the crisp evacuated reality of Godard (A BOUT DE SOUFFLE)[26] through to light-burnt images that produce idioms of "dream," "insanity," and "things remembered."

Thus far we have been discussing general exposure of the film or scene. There is also specific exposure within the shot. Most shots are composed so as to include brighter and dimmer

[26] In point of fact, Godard manipulated the surface qualities of this film through stock selection and processing technique, but the end effect was one that most people would associate with exposure variation.

objects. Obviously, a given exposure is ideal for only some of these objects, although others will be kept within acceptable exposure by the film's latitude. This fact places another linguistic tool in the hands of the film maker. He can choose to expose for this, or for that; he can cause objects to be balanced, or dark, or bright. At one end of the latitude of exposure, the film maker can dump unimportant or distracting data into the limbo of shadow. The other end of the continuum presents more knotty problems. It is not true that one dismisses data by causing them to burn white on the screen. Although the detail of overexposed data is lost, the intensity of their illumination attracts attention to them. Indeed, the very voiding of detail in the objects, combined with emphasizing their existence, sets the audience member to speculating on their meaning and importance, and does anything but cause them to disappear.

On the other-than-real level of film language, there is a great deal more to be done with specific and controlled overexposure.

Exposure alterations in color film change not only the brightness of the images, but also the color qualities, and therefore produce pictures less bound to reality. Manipulations in color exposure also create the "odd" and the "artistic"; they run the risk of arty effects that leave the experienced film maker and viewer wondering if he might not be being taken for an artistic ride. Nevertheless, control of color through control of exposure is an available and potentially valid tool, although it has not yet earned a place in the film language.

FILM STOCK QUALITIES

One of the controls (and therefore one of the channels) available to the film maker is his selection of raw film stock on which to shoot his film. Without overly technical description, the variants include speed, granularity, latitude, and contrast. In practice these are interlocked qualities. For instance, a "fast"

film will typically produce greater surface grain, less sharpness, and narrower latitude. But for convenience we may think of them as though they were discrete characteristics.

A film stock is said to be "fast" if comparatively little light is needed to expose it properly. For this reason, a fast film will normally be used when the film is being shot on real locations without studio lighting and in a more or less documentary style. The audience member does not see film speed; he sees graininess, softer edges, and rather flat images with which he makes certain unconscious associations.

Because of the effect of newsreels and because of conditioning through years of film-viewing experience, the viewer associates the visual experience of fast film with the real, the simple, the earthy.

Lens Characteristics

Another of the linguistic controls the film maker exercises over the visual part of his statement is his choice of lenses. Quite obviously—and to the vast delight of arty beings—one may depart altogether from reality by shooting with an anamorphic lens or with prismatic distortions; and one will get images that audience members recognize as some kind of maximal subjective state—such as insanity or great emotional distress.

In the documentary and narrative film, prismatic and anamorphic lenses are seldom used. Film makers and critics dealing with these mainstream films should have an understanding of the linguistic properties of the more common lenses. Granted a given action within a given frame, the film maker may choose to shoot with a normal lens (50 mm in the 35 mm film; 25 mm in 16), or he may go after the telephoto or wide-angle lenses.

The first effect of the other-than-normal lens is an alteration of depth of field, a language element already discussed. The

wide-angle lens will give the film maker a greater depth of field, the long lens a shallower one, and he will have all the linguistic advantages and limitations of field depth.[27]

The other major linguistic property of other-than-normal lenses is image compression and image expansion. One manifestation of image compression is the relation of environment to character; the other is distortion of spatial movement toward or away from the lens.

A wide-angle lens will move the characters away from their backgrounds, whereas a long lens will press them against their walls, desks, crowds. Obviously, the film maker wanting to deal with the effects of environment on the character, or one treating the Outsider who operates in opposition to his cosmos, would do well to look into the language of focal lengths.

This matter of using focal length to deny or to reinforce the effect of environment on the action is one of the many Sisyphean torments with which the gods of Theater and Print plague the film maker. The long lens, as we have said, tends to press the character against his background and to accent the effect of environment on the moment. At the same time, the shallow field created by the long lens tends to drop the background into the limbo of defocus. The environment is emphasized and attenuated at the same time—the one in space, the other in focus.[28] It is possible to control these countering effects by alterations in light, but changes in lighting during a sequence take time and money, and they plant seeds of distress that the editor will reap when he tries to match up the shots. Care, planning, and technical skill are the defenses the film maker has against the gods of bad filming, but in problems like these, he is also well advised to arm himself with luck.

[27] Like so many elements of film making, depth of field is a product of many variables. Changes in lighting intensity or in film speed (both of which result in changes in f-stop opening) will correct depth of field, and so it is perfectly possible to move to a wide lens without much altering the depth of field if one decreases light or shifts to a slower film.

[28] The opposite effect, of course, is found with the wide lens.

Distortion of movement on the axis of the lens has become a common linguistic element in recent years, particularly since the technical departures that constitute one of the characteristics of the New Wave. Anything advancing on or retreating from the long lens will appear to hover in space and achieve rather little distance, whereas the same movement registered through the wide-angle lens will make the mover seem to eat up space at a startling, often threatening, rate. The second effect cooperates well with scenes of confusion, argument, anguish; the first has a ghostly quality, or can be used to say, "he moves, but he gets nowhere," in all of its implications.

The choice of lenses is often dictated by the limitations of space (tight shooting quarters or impossible intervening terrain between camera and subject) or time (it is so much quicker to "rack" to another lens than to move the camera setup), and that the film maker is sometimes only minimally concerned with the special linguistic effects of the lens he has selected. But, want them or not, these effects will ineluctably impinge on the message of his shot, and if he lacks the time, money, skill, or vision to use lenses to his advantage, he must at least be sure his lens is not un-saying his message.

This broad section has dealt with such highly technical elements of the language as depth of field, focus, exposure, film stock qualities, and lens characteristics. Moviegoers do not leave a film praising or denouncing such matters, and critics and analysts seldom pay attention to these elements of the language they do not, for the most part, understand. But that elusive quality known as the "style" of a given film maker can more often be described in terms of image characteristics than in any other terms.

Camera Movement

Except in the instance of the subjective camera, camera movement of itself seems to create no considerable visual content, but it does qualify and organize other elements of the film language. Camera movement is also sometimes used simply to vary the visuals, particularly in the talk-loaded film versions of stage plays. (A typical example of this use of camera movement to escape visual stasis was WHO'S AFRAID OF VIRGINIA WOOLF?) But even when the camera is being moved as a defense against a greater ill, the film maker must consider its qualifying implications.

When a subjective (role-playing) camera is in motion, certain simple content statements are made without the action having to be presented on the screen: "Fred (the character for whom the camera is substituting) is walking to the door," for instance. Since no one has yet designed a realistic way of imitating the human walk with camera movement, the subjective camera tends to tone movement scenes with a dreamlike quality.

THE DOLLY-IN

This is a motion of the camera toward the principal subject. The shot changes from a wider, factual/environmental frame to a smaller, attitudinal concentration on some element within the frame. With this movement, the shot says in effect: "here is the environment," then "here is what is happening within and in terms of that environment." Because the focus and compositional center never leave the primary subject of the shot, the dolly-in insists that the closer composition be viewed in

terms of the environmental establishment of the wider composition. It insists on this even more emphatically than would a cut from the long shot to the closer shot.

The dolly-in may also be used to point out some object within the earlier, larger field. Here one finds a case of tighter composition that seems to reverse the general pattern by accenting a fact rather than an attitude. But the attitudinal concentration is maintained by the continuous exclusion of surrounding data and by a regular shallowing of the field of focus caused by the need to "follow focus" on a dolly shot.

THE DOLLY-OUT

This movement (the reverse of the dolly-in) tends to say, "here is what is happening," then "here is the environment in which it is taking place."

There is a special implication in the dolly-out that French film makers of the 1930's (following Jacques Feyder) used. Through the dolly-out, it is possible to spread the attitudes created in the closer shot over the whole of the field of the longer shot. If, for instance, two unhappy lovers were the subject of the closer shot, a dolly-out that opened the field to include other couples on benches or strolling about would tend to spread the possibility of fated unhappiness to these others as well. It is rather a pity that this generalizing effect has dropped out of the idiomatic language of the film, but such things are matters of fashion, and one may expect the device to be "discovered" again in time.

NOTE ON THE ZOOM

The zoom creates an optical effect that is similar to the dolly; it brings the viewer closer to or farther away from the subject.

It differs in that it operates through magnification and seems to send the viewer gliding through space in a way that does not conform with his experience of motion. The zoom lens is so constructed that, as we move in, we change steadily from a wider angle lens to a narrower one. The depth of field, therefore, undergoes considerable shallowing. Also, focusing is less precise through the zoom lens. For these reasons, the zoom has been called the "lazy man's dolly," but there are times when the device is mechanically necessary and times when the film maker wants the unreal qualities of the movement. The film maker has only to consider the ways in which a zoom is *not* a dolly before he substitutes the one for the other.

Pan Movements

Panning is the turning of the camera on its vertical axis. The horizontal movement produced by a pan may either follow action or move through a field of relatively still action. The latter case will be discussed now; the follow shot will be described later.

The panning of a camera through a still field can be viewed as a series of shots connected even more directly than through the cut. The relative motion of the data across the screen, which denies the audience member the ability to concentrate on any single object at his own leisure, tends to lessen the total factual or attitudinal implications of the pan shot as compared with a series of still cuts covering the same total field. Normally, the camera is still at the opening and close of a pan shot, so the data that form the content of the beginning and the goal of the movement have more quantitative weight than has any composition through which the camera moves.

For purposes of analysis, the pan may be thought of as a series of shots, a new one occurring each time there is a complete change in the field—that is to say, each time the data at

the right of the screen approach the left, in the case of the pan right. We say, "approach" rather than "meet" because of a perceptual peculiarity in the way the audience member deals with a pan: His eye tends to seek out the data being discovered, and he will generally focus to the side of the frame toward which the camera is panning, giving rather little attention to the "pan away" side. This is not true if the viewer selects a single object and tracks it backward across the screen, then "cuts" back to pick out a new one—but the film maker cannot very well predict or control this behavior, so he might as well not concern himself too much with this matter.

In a way very similar to the dolly action, the attitudinal implications of the opening of a pan tend to spread over the rest of the shot. There is always something unreal about the pan because it does not reproduce the viewer's way of looking at a wide area. A man does not pan over a vista; he puts it together in a series of "cuts" based on eye and head movement, often punctuated by blinking. This is why the pan is a rather shabby tool in subjective camera work. Nevertheless, it has its place in the film language.

TILT MOVEMENTS

Tilting is the turning of a camera on its horizontal axis; it produces vertical motion. In all essential ways, the tilt operates very like a pan: It connects the fields of view, the audience member seeks the "tilt to" edge of the frame, it spreads early attitudes to later fields, and it is an unreal effect in that it does not reproduce normal visual experience.

But the tilt has one important linguistic implication lacking in the pan: The tilt, altering as it does the angle at which the data are photographed, tends to render elements at one end of the shot more dominant than elements at the other end, depending on the direction of the tilt (up or down). Simply, the

tilt can be thought of as a vertical pan with all of the additional content possibilities we have discussed under the heading of Angle.

CRANE MOVEMENTS

These movements operate similarly to dolly movements except that they allow the camera to move up and down as it moves in or out. The crane relates to the dolly rather as the tilt relates to the pan: It has all of the same characteristics, but it also allows the film maker to take advantage of the linguistic properties of angle. Thus, a crane back-and-up can generalize an attitude created in the closer end of the shot while it presses the characters down into their surroundings, rendering them helpless, or dominating them by their surroundings through virtue of the high angle at which they are seen at the end of the movement.

FOLLOW SHOTS

In the follow shot the camera moves along with the motion of the principal subject. This may be done through a dolly, pan, tilt, or crane, although in the classic "trucking" shot the pan and tilt are not used because they operate from a fixed position and must, therefore, include an unavoidable change in field size (from mid-shot to mid-long shot, for example).

In every case, the principal subject is held in one field as it moves. Such a shot is most profitably thought of as a device for concentrating the attention common to the still shot on a moving subject, although we often see the follow shot used for no other reason than to give spurious visual life to long conversations—particularly in message films and stage versions. The environmental data around the principal subject are of

little content value (often, indeed, out of focus or blurred by motion) except to the extent that they serve to create mood or impinge on the action. To be sure, the background also adds, through its motion and blur, the implication of motion, possibly of speed. The film maker cannot depend on any content value in the background material because the speed and direction of the moving subject, rather than the film maker's desire to reveal information and environment, dictate the speed and direction of the camera movement.

Decor

Like lighting, this very significant element of the film language is very difficult to speak of in the abstract, although many important statements are to be found in the decor of any given film.

On the grandest level, decor is a function of location. A film concerning greed, for example, could be shot in a big city or in Death Valley, but different aspects of greed would be accented in each location—probably the causes of greed shown in the environment-loaded city and the effects and manifestations of greed would best be displayed in the barren desert. And von Stroheim did it just like that.

Location selection is so tightly linked to the script that major alterations are seldom available to the film maker. However, given a desert, the film maker can, through handling his decor, decide what kind of desert, what mood, what subtle implications he wants to attach to his scene.

Decor usually operates in three lines of content: information, attitude, and characterization. Informationally, decor suggests locale, era, and a wide spectrum of socioeconomic conditions. It also can generate broad emotional moods that will permeate

the fabric of the film: free or trapped, overwhelmed or over-whelming, outpouring or involute.

Decor also serves to reveal many elements of basic characterization. The taste, the education, and the aspirations of a character are often revealed by the decor of his dwelling or by that of the places he frequents.

Finally, it must be remembered that it is through decor as much as through framing that most of the content implications of composition are achieved or, at least, justified.

Titling

Modern titling is a far cry from the arid run of credits over a rattan background common to the thirties. Indeed, there are films today in which the titles possess the bulk of the creative imagination expended in the film.

When new trends and new technology are accepted into film making, their first appearance is usually in titling. Modern examples include the use of op art, split-screen effects, and negative color. One of the reasons titles are free to explore and expand the boundaries of free visual expression is that they are liberated from the burden of carrying content information (typically being superimposed over backgrounds that are either neutral or informationally redundant to the body of the film).

To a certain extent, titling serves to create the overall mood or environment within which the entire film is to operate. Titles can condition the audience member to gaiety; they can foreshadow heavy and dire events. The kind of typeface used in the lettering can bring the audience member into the Middle Ages even before the film has properly begun. Or again, the speed of the cuts between title and title can help to establish a basic tempo.

IMAGE AND IMPLICATION

"We strive for honesty and im t rat n." What is the meaning of the last word in this quote? It has none—all we see are letters and blank spaces. Yet, the reader will reject this and will try to deduce some "meaning" nevertheless. We gather and retain information by arranging it on the collecting anodes of meaning and intent. Because randomness and coincidental juxtapositions are alien to our methods of dealing with information—and because, by extension, they threaten our grasp of outer reality—we unavoidably attempt to impress conceptual groupings onto any constellation of data related in space or time, even if it means filling gaps. This principle is at the heart of montage. We resist saying, "Here is element A." Break! "Here is element B." We make every attempt to say "element A *plus* element B"; or "element A *therefore* element B"; or "element A *in terms of* element B."

The film maker converts raw sounds and images into a meaningful message by using the viewer's inclination to arrange elements into safe and tractable concepts, and he uses the experience he has shared with the viewer to project and bias his messages. He cannot work outside that shared experience. For instance, the letters of the "word" above were not really random. The writer was careful to imply "wordness." He did not dare juxtapose a *z* and a *j* because the reader would have rejected this combination as alien to the way words work in our language.

Given one visual element—one frame of a film—there are many ways in which the film maker can guide the viewer's experience into "meanings" that reflect the film maker's intent. These illustrations deal with some of the film maker's instrumental controls, and the frame above includes many of them. The reader might occasionally refer back to see how the pensive mood of the little boy is reinforced by angle, framing, lens characteristics, field size, and depth of field.

FRAMING

The visual world around the cameraman is a floored hemisphere, and his first task is to select a limited rectangle within this cosmos for presentation to the viewer. Implications of narrative intent, of composition, and of temporal juxtapositioning (subsequent editing) all impinge on his selection, but, in the end, framing is usually a matter of meaningful exclusions and meaningful inclusions. Out of the microcosm above, the cameraman might have accented and particularized, by exclusion, any number of individuals, and he might have included an infinite variety of environmental data to guide the viewer's reading of mood and inner feeling (see the frame on the preceding page).

The cameraman is also free to move his instrument around and through the whole event, creating new relationships between persons and between people and elements of environment.

In the following frames, the cameraman denied himself the tool of re-organizing the total event by vastly changing angle and azimuth. He limited himself to a few groupings-of-two in which, by both inclusion and exclusion, he unearths and accents relationships. The reader may play this game for himself and frame in or frame out information to discover more valid and meaningful relationships.

Depth of Field

By manipulating light, film stock, and shutter speed, the film maker can control his depth of field—the amount of visual information in sufficiently clear focus to impinge on the event.

This may be done with background information, foreground information, or both. Generally, the shallower the field, the more the viewer concentrates on the attitudes of the subject; and the deeper the field, the more the viewer is given information that relates (typically casually) to those attitudes. For instance, an angry child seen in shallow field, which denies detail by blurring the background, requests that the viewer deal with the anger. If the field is deepened, and the background reveals harsh and ugly slums, the viewer is asked to deal with the causes of that anger.

The cameraman's assignment in the two frames on the next page was to first establish a simple attitude. In this case he went after idiomatic depression using sterile backgrounds and posing the actor in a fetal posture. Then, by deepening his field (in this case to the foreground) he sought to add information that urged the viewer to consider possible reasons for the attitude of depression.

The reader might refer back to the first picture and notice how the highly informational clean focus of the model's legs and the weathered grain of the wooden steps offer possible reasons for the little boy's withdrawal.

LENS CHARACTERISTICS

Another tool by which the film maker guides the perception of the viewer is his choice of lenses. The frame above was taken with a normal lens—one producing a spatial relationship between the two actors that is similar to that seen by the naked eye at the point of the camera. In all three shots, the actors play the same unit (i.e., their emotional conduct remains constant), and they are the same distance apart. The cameraman chose to allow the position and size of the young woman to remain relatively constant. He then took the setup twice more; once with a wide-angle lens, once with a telephoto lens.

The characteristic spatial compression of the telephoto lens not only insists on the viewer's reading a closer and less casual relationship between actors, but suggests a domination of the scene by the male actor. The characteristic spatial explosion of the wide-angle lens accents the female actor, increases the felt distance between the actors, and unavoidably allows more environmental information to affect the reading of the scene.

Potential directors among you will concur with the following. It is not true that the forced distance of the wide-angle lens weakens the emotional relationship between the actors. On the contrary, the fact that they seem to be playing an intimate and intertwined unit across so much space suggests a greater energy and desire for contact. They love more, or need more than they do in the other frames.

To refer back to the little boy in the first picture. Because the shot was taken with a longish lens he is pressed into his visual surroundings and this denies the viewer the right to read him without reference to things around him.

ANGLE

In general, the down angle tends to lend the subjects qualities of subordination, inferiority, and subjugation. The up angle gives implications of victory, strength, and domination.

In the frame above, we see two actors working a conflict unit. The woman is seen dead-on—neutrally, in terms of angle. In the next two frames we see her playing the same unit from a slight up angle and a slight down angle. The lines of the forehead and mouth, the set of the chin, the body attitude seem to change implication as the angle changes. In the up angle she seems angry, dominant, powerful. In the down angle she appears worried, uncertain, hurt.

This bias based on angle (possibly having something to do with the up angle experiences of childhood) is one of the more delicate elements of the film language. Its implications are based on differences from some "normal" angle, and the film maker can decide what is "normal" in his own film. The attitudinal implications of angle are so fragile that they may be overridden easily by lighting, acting, framing, and other elements of the language.

The little boy had the involute qualities of his body posture and eye contact reinforced by a down angle.

FIELD SIZE

Here we have the traditional set of long shot, mid-shot, and close-up. It is obvious that the viewer concentrates more and more on the *attitudes* of the little girl as we close in; and it is equally obvious that we have more *information* concerning her cosmos as we pull back. As Eisenstein has said, the function of the close-up is not to make things larger, it is to exclude elements that might absorb some of the viewer's attention. When the film maker closes from the LS to the CU, the attention is concentrated on the principal subject, not only by the loss of secondary data from the edges of the frame, but also by the exclusion, through defocus, of background and foreground information.

Centripetal decay has been discussed at length, and the reader should examine this group of shots in those terms. On first glance, the long shot is "girl on steps with others." But if you continue to examine the frame, it breaks up into a series of selected mid-shots: girl's hands, tree, foreground girl, legs of foreground woman, etc.

On first glance, the close-up is: "girl in repose with some kind of internalization, possibly sadness." But if you continue to examine the frame, it breaks up into a series of mid-shots of fragments: an eye, the lips, sun in the hair, etc. This evolution of the LS or CU into a series of MS's under conditions of temporal endurance is what centripetal decay is all about.

Our little boy was taken in mid-shot because the cameraman wanted to include narrative elements around him. If you examine the long shot of the same boy on the next page, you will sense how much attitudinal involvement is surrendered when we pick up more informational elements of the environment.

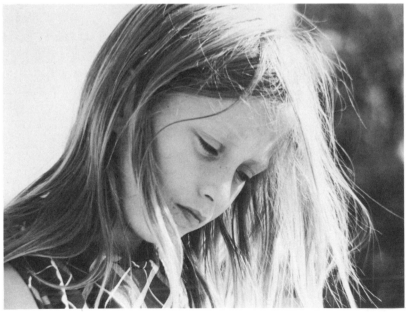

LIGHTING

The content implications of lighting are endless. Informationally, lighting is used to indicate place and time. The first three shots here give us time: morning, midday, and night. But the narrative and emotional implications of lighting are more complicated and also more interesting. Using the midday shot as a flat, unbiased average, the lighting man was assigned the task of bringing morninglike qualities of gentle hope into the facial lighting of the morning shot, and nightlike qualities of hard fatigue into the night shot. The actress plays the same neutral unit throughout.

Numberless frames showing lighting implications could have been shot. The last two are more variants of night interior lighting. In one, we have allowed the actress to sit in the dark, a streetlight beyond the window the only light. In the other, we have pooled the light on the table and kept it off the wall behind. Not only may the lighting man accent elements through illumination, he may force concentration on the attitudes of the subject by denying alternative visual information. In a way of speaking, the mid-shot may be lighted so as to work like a close-up.

Forced narrative is another element of communication through lighting. Consider the last two pictures. As the viewer wonders why she sits in the dark, or why there is only one overhead light cutting harshly onto the table, he develops creative narrative that lends attitudinal qualities to the shot.

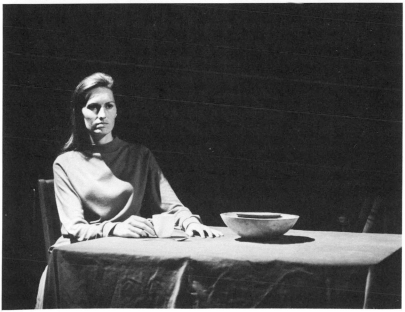

The backgrounds used for titling can transfer content. The most effective and obvious instance of this is to be found in those titles that work over the opening scene or scenes of the film, or over freeze frames out of the film. It is difficult to say what value the film maker ought to give to the content of shots used under titling. Certainly, the shots and all that they mean are present, but the audience member is blocked from viewing them fully by the intervening titles. One can safely say that no major plot point had better appear under titles unless the film maker is seeking the obfuscations so often mistaken for profundity.

4

Audio Content

Edison's first interest in the motion picture stemmed from a desire to spice up his already popular phonograph with something visual. Some models of a more or less synchronized device for simultaneously seeing and hearing performers do a vaudeville turn were developed, but because of popularity and continuous maintenance difficulties the project was dropped.

At all events, linkage between sound and images was an area of mechanical—if never artistic—interest throughout the silent years of film. It was not, however, until the brothers Warner decided to gamble what was left of their failing company on the novelty of talkies that sound became a part of the film language. The gamble paid off. The mass audience devoured the new gimmick, and images were brought at the point of a shotgun to the economic altar where sound waited, trying hard to blush.

The early offspring of this morganatic union were not promising. The camera, which had just achieved the power and freedom of early adulthood through the German Street Film movement, was suddenly trapped in clumsy soundproof chambers, unable to move at will, wincing under the domination of the microphone. More harmful (because less brief) than the spatial enslavement of the camera was the arrival of the visually illiterate theater with its talking actors and talk-oriented directors. Despite the notable exceptions of Mamoulian and Clair,

the first years of talking film saw the pictures reduced to the role of carrier for the dramatic form.

In time, technology silenced and liberated the camera, and directors learned to make films, at first despite, later in cooperation with the sound track.

Audio content in the motion picture can be broken down into three large classes: verbal, musical, and sound effects. Music and film had many informal unions before the advent of the talking film, and came quickly to cooperate and reinforce one another. Sound effects, linguistically more like music than most analysts seem to recognize, were the next to come under control. The battle between words and images rages still. We live in the shadow of a reluctantly retreating verbal culture. Men prefer to organize their experiences in space (usually on a page), rather than in time as does the film. They can handle experience that is arranged linearly (like print) better than that which is arranged cumulatively (like film). So critics and lecturers on the film have chosen to deal with the words of a film and with interpretations that are comfortable in a spatiolinear culture.

Another reason for the unrealistic critical preference for words lies undoubtedly in the relative ease of reporting verbal symbols through verbal media, as opposed to the task of reporting visual content through a verbal medium.[1]

After the felt or implied sound of the silent film (the "doorslamming" passage in Keaton's THE NAVIGATOR, or the trumpet sequence in THE LAST LAUGH), the microphone became an aesthetic tyrant. Then a tyrant tamed. And now sound constitutes an element of the language that is, in many films coequal with the images.

[1] A difficulty met, and not totally overcome, in the last section of this book.

Verbal Sound

One thinks of the verbal elements of the film as either synchronous or nonsynchronous. Words accompanying the images synchronously are called dialogue. Nonsynchronous messages may be either narration or commentary.

DIALOGUE

Dialogue is understood to be the speech of characters, either visible or known to be within audio range of the image on the screen. This definition is almost insultingly obvious; what is less commonly known is that meaningful sounds other than words (grunts, sighs, whistles, sobs) are also dialogue.

For the actor and the director, but not always evident to the viewer, there is also preverbal and nonverbal dialogue—that which is called "subtext." The discussion of subtext ought to be left to the section on histrionics, but because the film maker treats it as though it were spoken dialogue, some mention of it should be made here.

Subtext is the internal dialogue with which the actor generates his behavior. So far as dialogue goes, we see subtext in action in the nonverbal responses to other characters or situations. For instance, one character may make a statement which another doubts. The actor may manifest this doubt, not in the verbalized dialogue pattern: "I doubt that," but in a simple lift of eyebrows. Although no word is spoken, the actor must carry the dialogue line, nonverbally, in his internal subtext, and any audience member or analyst would know that the doubt had been expressed.

Subtext is also one of the channels through which the direc-

tor guides the work of the actor. The director can give (or, better yet, draw out of) the actor lines of subtext that crystallize the inner motive, much as the writer's dialogue crystallizes the outer manifestation.

Spoken dialogue is the most easily available of all content indicators for the audience member, the critic, or the content analyst. We get a great deal of information from the pure sound of the dialogue—forgetting for the moment the words and their meanings. Tone, accent, word selection, breath patterns, etc. tell us such basic things as the age of the character, his educational background, his aspirations, his ethnic and regional origin. Emotional states of the characters can also be determined in large by the volume, constriction, and rapidity of delivery, although this is more true of the extremes of emotion than of subtle shadings. From the point of view of emotion, dialogue can be thought of as the music people make in rapture, or the noise they make under pressure.

A specific reading of the words of the dialogue gives us evidence of the characters, their motives, the attitudes and value structures obtaining in the film cosmos; but one must be careful not to confuse the motives and values expressed by one or two of the characters with those generated by the film as a whole. For one thing, in any well-written screenplay we have the words of a character as he cares to (or dares to) reveal himself to another character—not the same thing as a total self-revelation. Secondly, it is not uncommon for a good and subtle screen writer to produce major statements by displaying the difference between the values and motives claimed in words by a character and those proclaimed in his actions.

Good screen dialogue is an extension of the actions of the character. It should neither be redundant to action nor should it replace it. If the marriage between theater and film inflicted any lasting damage on the art, it was probably the collision of dialogue with the native language of the film.

COMMENTARY

Commentary is nonsynchronous speech heard by the viewer while he is watching a shot or sequence. This verbal message usually serves to introduce, explain, weigh, or modify the visual statement. In the well-made film, the redundancy of this verbal information to the visual information is held to a minimum. Failure to do this is the trademark of the worst of the teaching films.

Commentary comes to the viewer from an unknown and omniscient source (representing, usually, the film maker) and is held to carry the unbiased truth. Except for the few instances in which commentary appears in a film within a film (as in the opening newsreel sequence in CITIZEN KANE), all sense of illusion is lost through commentary, which is most often found in newsreels, travel films, commercial and industrial films, teaching films, and documentaries.

NARRATION

Narration is also nonsynchronous speech, but it differs from commentary in that its source is some character in the film, or someone related to the events in some known way. It is important for the analyst to recognize that narration, being the voice of a fictional character with his own biases and attitudes, reports on events and actions in terms of particular points of view that will be based upon the characterization of the speaker.

Music

There are two broad classifications of music in the film language: local music and background music.

LOCAL MUSIC

This is the music coming from an identified source. It is the radio on a table, the night club orchestra, the actor playing a piano (usually rather unconvincingly), or any other source that has been established through the images and the narrative. When this source has been established but no longer appears on the screen, the line between local sound and background sound becomes vague.

Rather a lot of content is channeled through the musical indicators of the film language. The kind of music a character plays or selects tells us something about his tastes and about his aspirations. Beyond this revelation of character, local music serves two other functions: First, it intensifies the locale with which it is identified; second, it establishes a creditable source for what subsequently operates like background music.

A Western saloon is more of a saloon when a tinny, piano-roll sound is added in. What is more, even when the saloon is not on the screen, its existence can be implied by the distant sound of its local music, and herein lies the greatest content value of local music: It makes it possible to blend two lines of content simultaneously. The same effect can be achieved for a nightclub, a concert hall, or any other place where one can usually expect to hear music. Not only can the physical entity identified with the local music be implied within the music, but all attitudinal attachments—all things that happened there or were felt there—are likely to be carried into the new shot.

The narrative song in the musical comedy is a rather special instance of local music. Often the words and the songs must be dealt with as dialogue—the actor speaks to another character or soliloquizes to the audience to tell us he is unhappy, over-burdened, in love, or just feeling especially peppy today.

BACKGROUND MUSIC

Background music is a more complicated and more important affair than local music. It swells in from an unidentified source to lend mood and intensity to the scenes over which it plays. Because of the era during which the film form came into existence, and because of the mechanical fact that what is before the camera is what appears on the screen (a loss of selectivity that no other art is burdened with), the film has a native proclivity for the real. One might go so far as to say that realism found its most compatible home in the film form. It is significant, therefore, that the film has always relied on the totally unrealistic support of background music, which has become so idiomatic that the average filmgoer is unconscious of its presence. And it is precisely because background music operates on a level other than the conscious that it can affect the audience member so subtly and strongly.

In the case of some background music we find a reversal of the usual roles of image and sound. The music establishes the noun, the images provide the modifiers. The music says "there is love" or "there is danger," and the images assign these general statements to the love of Alice for George or to the danger of that fellow lurking under the trees.

Another use of background music is found in the leitmotif, a musical theme with which a certain event or character is identified by transmitting the two signals (character or event, and music) simultaneously until they have become counter-identified. Classic examples of this are to be found in the theme "Diane" from SEVENTH HEAVEN (Borzage) and in the "theme" from THE THIRD MAN (Reed), and more recent and complex leitmotif structures appear in the Rota/Fellini score for LA STRADA.

Once the cross-identification between music and event or

character has been established, the audience member will accept any appearance of the leitmotif as a minor occurrence of the event or character. However, one significant factor that interferes with this pattern is that film themes often become popular through radio and recordings before the viewing of the film, and the audience member comes to the film with preestablished attitudes toward the music.

Syntactically similar to the leitmotif, but weaker because of its obvious mechanics and nonfilmic base, is the musical symbol. National anthems, typical carnival music, or the "Spring Song" (either Mendelssohn's or Grieg's, both of which have come to represent "dawn"—rather comically) are examples of common musical symbols that can be read as minor occurrences of the things they represent.

Still another function of background music is its binding effect over a group of shots—that which Eisenstein has called vertical montage. This language element is mentioned here because it deals with music—usually with background music—but it will be fully discussed in the section on montage.

Thus far we have examined examples of background music as it cooperates with the visual aspects of the language. There is another relation between music and images: the contrapuntal, in which the music seems to work against the images.

Contrapuntal music functions in either of two ways: It intensifies the visual line through contrast, or it creates a new and satiric message out of the conflicting statements of image and music.

If a passage showed a little girl lost in a carnival crowd, the sadness of her predicament might be reinforced conventionally through low tempo, minor-key background music. But a greater sense of misfortune might be achieved by setting the same images against the gay calliope of the setting. In the latter case, the music would work contrapuntally against the images to intensify the mood through contrast. The first instance was simple emotional redundancy.

The satiric use of music against the images always presents the attitudes of the film maker, not of the characters in the film. Effective use of satiric counterpoint was found in TOM JONES in the scene in which a pious congregation pelted a fallen woman with mud while the Lutheran hymn "A Mighty Fortress" was woven into the background sound to make its ironic comment on Christian brotherhood in action.

Sound Effects

There are three general rubrics for the function of sound effects in the language: local sound, background sound, and artificial sound. It should be pointed out at the outset that sound effects tend to operate rather like music, and rather unlike dialogue. Indeed, in the making of a film, sound effects are generally laid in on a separate track just as music is.

LOCAL SOUND

Local sound (like "local music" the label is borrowed from the painting term "local color") is any sound made by any identifiable source in the visual content of the film. Such sound is, of course, naturalistic. If we see a man walking and we hear his footfalls, this last is local sound. And so with closing doors, ticking clocks, passing traffic.

Inasmuch as the film maker has control over local sound (most of which is mixed in after the photography) and may either include it or not, accent it or not, it is evident that he intends to transfer some content through it. The fact that elements of local sound are blended in and out of the sound track at the will of the film maker and are not continuously available to the viewer does not affect their naturalism. What audience

member has not experienced this aural phenomenon in his listening life? The ticking of a clock in a room is inaudible until one's attention is drawn to it. And that ticking can be felt to "fade in" and "fade out" as one's focus strays to and away from it.

Local sound is not completely within the control of the film maker, however. Although he can control the kind, volume, and character of the sound, he is not free to include or exclude it arbitrarily because its exclusion might produce "boomerang" content—in this case a strong feeling in the viewer that the sound is significantly missing. For example, if a character on the screen were seen to drop an armful of books, but those books made no sound when they hit the floor, the audience member would react uneasily and either read "dream sequence" or (more likely in this mechanically hip world) "something's wrong with the projector."

In almost all circumstances local sound serves to reinforce the image. A passing tram is something more of a passing tram if the roar of its passing is heard. We have demonstrated that the film maker is not free to allow the tram to pass silently, but he can decide how important he wants to make the incident by the volume and character of the sound he attaches to the image and by choosing or not choosing to allow the sound to override the dialogue, and therein lies the greatest linguistic control of local sound.

In a discussion of local sound some mention must be made of "presence." Wherever you are as you read these lines, you are surrounded by sound. You might think that you are in a condition of silence merely because you are not attending to any specific sound of known source. But if you pause for an instant you will begin to hear the myriad minute sounds by which you are surrounded. Some of these come from identifiable, low-volume sources that you have grown used to so totally that you include them in your functional definition of silence. Others are not identifiable; they are simply the low-level ambient

composite of you and your environment: your breathing, distant sounds of traffic and night, the settling of your house, the air echo of your study, etc. Complete silence cannot be achieved without the aid of complicated scientific apparatus and, as we know from past experiments, is neither a desirable nor a comfortable experience, Proust notwithstanding. In the film, theoretically, silence is possible—one has only to run a blank tape. (In reality, the sound of the amplifier and the natural sounds of the space in which the blank tape is run would combine to produce an audio experience that is not completely silent.)

If a film maker wants a particular moment to be "silent," he must fill it with a "presence track," a recording of the characteristic silence of a given locale with its low sounds and personal timbre. He does this so that the audience member experiences what he would call silence, rather than the ringing void of an arrested and artificial world.[2]

BACKGROUND SOUND

Background sound (or environmental sound) is the sound produced by unidentified but recognizable sources, as, for example, by traffic, by a radio down the hall, or by machinery. It differs from local sound in that its source never needs to be shown specifically on the screen.

The content significance of background sound is a complicated and interesting problem. At minimum, each instance of the sound is read as a minor occurrence of the source. For instance, the background rumble of traffic constitutes a minor incidence of "cars" and "streets" and whatever these mean to

[2] Exception here: The film maker might use blank tape to produce a palpable, ringing emptiness following loud noises, such as gunshots. But he would not be seeking silence; he would be trying to reproduce the subjective sound of shock.

the viewer. But a background sound may also be read as a major occurrence of the meaning of the sound. For instance, the constant ticking of a clock through a series of shots showing a character waiting for something might be viewed as a minor instance of "clocks," but it would also be a major occurrence of the element of "time." Similarly, marching boots might be a minor occurrence of "army," or it might be a major indication of the condition of "war" influencing the actions of the characters in the passage. (None but the most compulsive of quantitative analysts—and no film maker—would read such a sound as an instance of "boots.")

Background sound also establishes environment (both mood and locale) in terms of which the passage is to be understood, or in terms of which the action is to receive its significance. In such cases it operates very much like background music. As an extension of this function, background sound can also operate like a leitmotif of noise, once the specific sound has been identified with a character, event, or setting.

Rather like music again, background sound can work vertically to bind together a group of shots, making them interdependent and intramodifying. Any two shots seen while a continuous sound runs through both, must be read in terms of one another by the viewer.

ARTIFICIAL SOUND

Artificial sounds have no identifiable source outside the cosmos of the film. They are produced electronically or through the mixing of natural sounds (reversed, sped up, slowed down, etc.) to make an unnatural one. The term "Mamoulian Stew" is used by film makers for such sounds in honor of the first director to use the effect, Rouben Mamoulian (DR. JEKYLL AND MR. HYDE, 1932). Typically, artificial sounds occur in fantasy and in science fiction films, or in passages dealing with un-

natural states, such as insanity or nightmare. Often they support the visuals in an extranatural transition of one kind or another, and they are not atypically accompanied by some editorial device of the less common and unstable kind, like the wash.

Linguistically, these stews operate very much the same as do leitmotifs: Once the sound has become identified with the event, state, or transition, it may replace the visuals. Not only does this save money and the work of the special-effects man, but it also creates highly potent visuals generated within the imagination of the audience member.[3]

SOUND BIAS AND CONTROL

Up to this point we have dealt with sound in the film language as though the sound were pure and clean and had no special qualities of its own. And by and large this is the case with the sound of slick studio films still recorded in the sharp and "frightened" styles of the early thirties. The quality of speech and music in the average sound film is unrealistically clean and pure—almost without perspective, ambience, distortion, attention fluctuation, and the other qualities that sound in life has (albeit these qualities are unnoticed by the average, untrained ear). The fragile, unsophisticated sound equipment used in early sound films demanded great caution and work to get sound that crossed the line of understandability, and it is only natural that "clean" sound and "good" sound became synonomous. It is unfortunate that, outside the mode of documentary, these early frigid inhibitions clung to film sound.

During the young and relatively low-budget films of the New Wave, a more natural approach to sound was made—to

[3] In this, the visuals generated by artificial sound are similar to those powerful, but unspecific, visuals radio drama used to create when the rustle of wind in a tree produced each listener's personal and valid tree.

be honest, primarily because there was neither equipment nor money for "good" clean sound. And today we find a few young sound men who are daring to use distortions and perspective, mixes and tonic qualities to reveal character, set mood, bias the message, and in other ways cause the sound to resemble the liberated camera in its ability to control and affect content.

In this use of biased and liberated sound, documentaries, sci-fi, "coastal" schools, and horror films are far ahead of the world's slick major studios, but with the regular transfusion of younger blood, we can look forward to a time when sound will come of age in the film language.

5

Editing and Montage

Sounds and images were elements of artistic communication long before the advent of the film. But it was the film that allowed these channels to be blended in unique and telling ways not previously available to the artist. If film had made no other contribution than this blending, its claim to being a novel language would be fragile indeed. The language possibilities of time and motion constitute the special channel native to the film and absent from the other arts.

In the preceding sections—when we were looking into the development of audience, content, and basic equipment in an attempt to show the bases upon which the modern language was built—we placed considerable emphasis on the appearance of motion as an artistic and scientific concern, and upon the technical machinery produced to capture and broadcast this motion. Motion through time and motion through space are the unique artistic qualities of the film form. And the time–space controls of the film are more in the creative hands of the editor than in those of any of the others who contribute to a film.

Film critics who are not film makers often speak of editing and montage in the same breath, as though they were the same thing. It is true that some montage effects inevitably occur over any cut; that editing devices, such as dissolves, have an

effect on the montage implications of juxtaposed shots; and that the same man with the same vision affects both the editing of a film and the creation of its montage. But there are significant differences in goals and approaches between the task of editing and that of creating montage.

Editing is the ordering and enhancing of the image and sound elements of a film; montage is the creation of content through juxtaposition. Many films are joined together without the greater sophistications of creative editing; many films are well edited without the slightest view to montage.

We fully recognize the similarities between editing and montage, yet we will deal separately with these two elements of the language.

Editing

The editor is the last runner to carry the olympian torch, and as such he is responsible for maintaining the premises, the time and space compositions, the feelings and goals of the film. His role is not only preservative; he also makes major personal contributions in the areas of continuity, correction, cutting rate, and tempo.

CONTINUITY

Under this heading fall all the problems of shaping the raw sounds and images of a film into a form that contains and transmits its message. In some filmic modes, especially the narrative, the editor's responsibility for linking element to element is shared by—often usurped by—the writer and the director. In the documentary mode, continuity is much more in the hands of the editor, because the writer can rarely predict

the exact content available, and the found locations and stories often emerge in the film making at some time later than the original conception. At the freest end of the continuum—in the film of visual art, it is not possible to conceive of creation prior to and excluding editing, because the shaping of the material constitutes the greater part of the content.[1]

One thinks of editorial continuity on two levels: the simple plane of action continuity within a sequence; and the grander plane of the logical and artistic shaping of an entire film.

On the simpler level, the editor must cut from shot to shot in such a way as to maintain a flow of internal action that does not upset the audience member's sense of how things ought to be. This "match-action cutting" requires technical experience and a good kinesthetic sense, but it produces no linguistic content in the realistic passage (although failure to do it well, will harm the illusion of reality). More interesting to the film maker, the analyst, and the critic are the special properties of the "jump cut"—the cut that does not match action in spatial flow, time sequence, or location.

Before looking into the jump cut, there is an editorial phase midway between the match-action cut and the jump cut that is deserving of some attention, if only because its use constitutes one of the marks of the clever editor. We speak of the "compositional back-cut." [2]

The editor is faced with an intriguing problem in a passage meant to be cut for match action, but which contains two successive shots with saliently different compositional centers that cause the audience member to seek out the major figure for an instant before locating it on the screen. If he cuts exactly on a match of action, there will be a felt lapse—an action hiatus— in the flow of movement while the viewer locates the central figure. To avoid this, the clever editor cuts the second shot

[1] We shall ignore the concept of "cutting in the camera" in this discussion because this phrase of convenience really means no cutting at all.
[2] This bulky label is our own.

back a few frames (perhaps a twelfth of a second) repeating a fragment of the action so that, when the viewer locates the major figure on the screen, he will have a sense of continuity. On a technical level, this would constitute a kind of jump cutting, but because the goal of the editor is to create a regular flow of action, it is better looked upon as a device for maintaining match-action flow.

The most common use of the jump cut is between sequences. In this case it operates as a "forced logic cut," which we have discussed under the heading of Editorial Devices. The forced logic jump cut carries the central figure from morning to evening, from indoors to outdoors, from dressed to undressed on a simple cut, without the dissolve or fade that would, in past times, have served to indicate the end of a sequence and the beginning of another. The audience member's logic prohibits him from imagining that these events could have followed one another without a lapse of time. Consequently, he accepts the idiom and moves to the new sequence without experiencing a fading of interest through a major editorial device and with the special excitement that filmic manipulation of time produces.

Jump cuts can also be used within one space and time to produce an other-than-real effect—an effect of time remembered in fragments, or of things experienced under the pressures of passion, fear, etc. The use of this kind of jump cut produces high visual excitement—particularly when the frame remains firm and unmoving and the character is popped about within it—but it requires that the effect be designed by the writer and shot skillfully by the cameraman. The editor alone cannot affect internal jump cutting out of a mass of raw footage. Some attempts to save a dull passage by random internal jump cutting have typically only added confusion to dullness and produced an epileptic visual drivel that only the rarest of buffs would find profound.

Editorial continuity on the higher plane of shaping the total film plastic into continuous content requires the collection and arrangement of the audio and visual data on some considered anode.

Following a developing story line or plot is the most obvious and the easiest organizing principle for the editor (although the restrictions of plot on such matters as tempo and time composition present the creative editor with irritating limitations).

Another approach to continuity is temporal, cyclic, or diurnal arrangement. The film is organized in terms of its greater time—a typical day (never really typical) in the life of X; from rainfall to freshet to creek to river to ocean; biographies taking us from the humble cottage to the palace; he gets out of bed, goes to the coal mine, has a beer with his mates, argues with his wife, beats his children, goes to bed, gets out of bed, goes to the coal. . . . All of these are examples of the temporal, cyclic, or diurnal approaches to continuity which appear more in the documentary and semidocumentary than in other film modes.

Again, the editor may handle continuity in terms of cause and effect—one of the most telling of propaganda tools and a technique common to documentary and sociological films. Beyond the normal disposition of the audience member to fancy that the first thing he is shown happened in time before the second thing that is presented to him, there is a tendency for him to imagine that there is a cause-and-effect relation between the two, the first being the cause of the second. This fact permits of vast adjustments on the truth. Take the case of a narrative in the following set of shots:

1. MLS: Woman seated woodenly in chair, staring directly front, expressionless, a gun in her hand. She is at a window.

1. No sound

| 2. CU: Woman's hand suddenly clenches into a fist. | 2. SFX: Gunshot |
| 3. LS: High angle. Man runs down narrow alley. | 3. SFX: Running footfalls |

By rearranging these shots it is possible for the editor to manipulate the audience member's sense of cause and effect to produce many logical effects: Man shoots woman and runs away; Woman sees man shoot someone then run away; Man sees woman shoot someone, and he runs away; Woman shoots running man; etc. All these rather significant differences hinge on editorial continuity.

The manipulation of logical continuity allows the editor to decide whether the Germans attacked Poland upon provocation, or whether the Poles fought back after being attacked; lets him create the feeling that the police caused the riot, or the black nationals did; and other such shapings of fact. The morality of this kind of biasing of fact is beyond the scope of this book, but the principle has been used in numberless instances, all of which go to prove that, although it is said that the camera never lies, the editor is uniquely capable of causing the truth to cleave to his interests.[3]

After story line and cause and effect, there are other, less common organizations that affect the content of a film through continuity. It is, for instance, possible to organize footage of locations and places in terms of geographic progression and to

[3] Apropos of this: Two of my assistants recently did an experiment in which they used footage taken during a minor Civil Rights demonstration. In their first venture they were able to make the event look either violent or comparatively peaceful. This did not impress me too much, because it was a simple matter of inclusion or exclusion of footage that someone less well trained might have been able to do. Reacting to my disinterest, they tried another, more impressive experiment. Using exactly the same footage each time, they arranged it so as to make, in the one instance, the police appear to have caused the violence and, in the other, the Negro demonstrators. This is a case in point of control through logical continuity.

construct entirely different space and relations between spaces. It is also possible to use movement (camera or subject) as an organizing principle. There is also the matter of character revelation as a basic organizing plan.

This last consideration brings up a peripheral matter: the nature of the film hero. It is not only the person with whom we identify, or the person who represents the "good," or the person who appears in most of the footage, who may be called the film's hero. There is also the character who carries the camera with him. Unlike the stage or the novel, the film allows us to have a continuity hero who conducts the camera from place to place, and he need not be a major figure or even a particularly sympathetic one. The use of this other kind of hero to present two visions of a set of events has not been explored extensively at all, and so it remains one of the horizons available to the new director.

Whether the cutting is done by an editor or is conducted by a writer or a director, the basic continuous organization of the material is the first task. In the case of the film of visual art, it is one of the most important elements of content. In the documentary, it assigns magnitude and responsibility to events. In the narrative, it is a thankless task. A good editor can very rarely save a failing fiction film by reorganizing its continuity, but a skill-less one can do astounding damage.

CORRECTION

I guess one must talk about the corrective applications of editing, despite the fact that the critic, the filmgoer, and the analyst never know that these operations have taken place; but the "what to do till the doctor comes" role of the editor has so many varying facets and is so particular to the problem at hand that it is difficult to speak in anything but the broadest generalizations.

Obviously, the editor corrects, either by advised use of his trash bin or by arrangements with the laboratory, basic faults in the recording of image and sound.

More subtle and more creative aspects of editorial correction than simply chucking out junk footage are found in the issues of "eye-guide" and "thrust." Regardless of the care with which a script is planned and storyboarded, there will be times when shots designed to juxtapose will come to the editor with different centers of focus and varying internal thrusts.

Eye-guiding is the task of directing the viewer's point of focus on the screen so as to avoid jarring changes in the center of action when the next shot appears. To be more exact and sophisticated, well controlled eye-guide dictates the amount of change in the location of the interest center from one shot to the next. Normally, the editor is seeking a smooth flow that mutes the impact of shot after shot, particularly in a sequence of continuous action. But there are also times when the exigencies of cutting tempo (to be discussed later) and desires for "hard" cuts (discussed previously) dictate that the centers of focus be something other than coincidental. There are also cases in which the subtle editor will intentionally direct the eye to one side of the screen when the action of the forthcoming shot is at the opposite side because he wants to cause the sweep of the viewer's glance to pass over some relevant, but unaccented, bit of visual data. To be sure, we are speaking here of a level of editorial sophistication seldom encountered, except when a versatile film maker is cutting his own film, and never seen in the end-to-end cutting of the various Hollywoods.

A more knotty problem in editorial correction than eye-guide is adjusting problems of thrust. Disparities in thrust occur when two shots are to be united in which a continuous action is covered in two setups, or in two takes. Often the actor performs an act with noticeably more energy in one of the shots than in the other, or in a different way. The editor who cuts together two shots with unmatched thrusts will produce a

feeling of jump no less upsetting than the spatial jump cut. Normally, thrust problems are insoluble, because they should have been noticed and corrected by whoever was handling continuity on the shooting floor. The tantalizing problem is that, as the editor moves back and forth in his footage to find a place at which the cut can be made with a minimum of thrust disparity, he usually discovers that he will be caught in an action jump if he avoids the thrust jump. The best he can hope to do is to attenuate the obviousness of the thrust jump (most audiences are so used to Hollywood insouciance in this matter that it will pass unnoticed). If he attempts to compromise between his thrust jump and his space jump, he will suffer the punishment of all compromisers: His cut will jump both in space and in thrust.

Changes in the actor's emotional level between one take and another, or between one shot and the next, present problems very similar to those of the thrust jump; but the editor at least has the advantage that most audience members would call the histrionic change "bad acting" rather than "bad cutting."

The final kind of correction the editor can make affects the acting performance, particularly the pacing. This is a fairly obvious matter. The editor can sharpen cue pickup by collapsing the ends and beginnings of shots; he can cut around particularly sloppy action (typically overacting) by staying with or inserting a reaction shot; he can sometimes even create action that was never in the original script.

A case in point of this last, rather extreme, type of correction: In a recent film, [4] which included a vigorous argument between two men, we realized, upon viewing the rushes, that the actors were pushing the latter part of their conflict far more than the matter at hand justified (they were reacting beyond the logical needs of the unit). Shooting the scene again

[4] STASIS, 1968.

was out of the question fiscally. Leaving this particular part of the argument out was also impossible because it contained needed plot advancement. We decided that some physical contact between the men was the only thing that would justify their histrionic excess, but we had shot no such scene. For a few hours we considered committing suicide, but that smacked of the same kind of overresponse to stimulus that we regretted on the footage. Our editor came to the film's rescue by creating a slap out of the following outcut footage: The sudden movement of a hand toward a package of cigarettes. The sound of a slap recorded in his back room. The flinch of an actor dodging the sudden thrusting in of a clapboard. And a relatively expressionless shot of one of the actors whose eyes were tearing because he was repressing a sneeze (which sneeze, by the way, had ruined that take).

An editor who can correct and "save" footage is a great asset to any film, but the director should control (indeed, cut himself, if he is technically competent to do so) any corrections of acting.

Cutting Rate and Tempo[5]

Cutting tempo is the visual opposite number of rhythm in verse or beat in music. A film's tempo is a composite of many factors: cutting rate, music and dialogue rhythms, action within the shot, camera movement, the viewer's interest in and attraction to the shot, and a regulation of relative tempos within the film. Good tempo is one that is appropriate to the

[5] An excellent discussion of the rudiments of rate and tempo is available in Raymond Spottiswode's *A Grammar of the Film* (Berkeley, Calif., University of California Press, 1950). Unfortunately, Spottiswode does not deal with such concepts as relative tempo, the shot of high internal action, cutting volume, and the role of music in tempo. These concepts will be discussed in this section.

film or sequence. There is no abstract ideal tempo, and the editor who depends only on high tempo and excitement can do great damage to lyric and minor-key scenes. In a given film, too high a tempo can result in confusion, obfuscation, and a failure to communicate. Too low a tempo makes for a dull film. Unfortunately for the editor, who is largely responsible for developing a proper cutting tempo, there are factors beyond his control that affect the tempo.

One of these factors is the film's mode. The fiction narrative mode grants the editor the least freedom to cut for tempo. There are necessary actions, necessary lines, necessary sequiturs and—most unhappily of all—necessary total lengths: Television wants its fifty-five or so minute hour; and the downtown theaters have no use for the sixty-two minute film. The documentary, the archive film, the film of visual art all grant the editor more freedom in tempo, more selection in shots, and generally more latitude in total length (unless, of course, the film is designed for television).

Another factor governs cutting tempo, one that is not only beyond the editor's control, but even beyond his conjecture: the audience. Since cutting tempo is in part a subjective effect, audience disposition counts a good deal. Individual viewers vary in levels of film literacy, in depths of identification with the characters, in interest in the setting, problem, or situation. What would be a good cutting tempo for one viewer might be too slow or too fast for another. A general rule of thumb for the editor is that any recognized tempo is bad. First-class tempo is so right to the feelings of the scene that it goes unrecognized by the audience member, with the exception of the film professional who might enjoy the rare experience of a film that is not cut too slow.

Unfortunately, the editor cannot rely much on the response of a trial audience because none but the most sophisticated recognize the effects of tempo. Others will report that the acting

was brilliant or poor, that the story was turgid or crystalline, that the action was crisp or redundant—when in fact the good or the bad rests with the cutting.

How long should a shot be? Certainly it must hold on the screen past the threshold of recognition, and the location of this threshold depends upon the amount of data in the shot and the audience member's familiarity with the locale, characters, and motives. Somewhere beyond this line of recognition lies the band of cognition—the time during which the viewer deals with the shot, receiving its meanings and implications and blending them with his personal experience, interests, imagination, etc. And past this, the shot is too long. Ideally, the shot would endure on the screen to the last instant of the cognition band (or a bit less), then change to an associated shot that would benefit from the lingering and overlapping fragments of cognition. In feet and frames? Not an arithmetic problem.

With these vague and unpredictable factors governing cutting tempo, the editor does best who cuts to his own taste, modifying this in recognition of the lower level of familiarity, lower sophistication, relative indifference, and absence of proprietary solicitude in the audience member. The editor must also recognize that he has seen the footage numberless times and can predict the matter and thrust of the fim. If he cuts solely to delight his own sense of tempo, the audience member may be faced with a Mekas-like gallimaufry.

If it is the director or the writer who does the cutting, the dangers lie at the other end of the continuum. A kind of parental megalomania often impels him to keep each frame of footage, each immutable word, and he tends to cut in a soft tempo that sends the audience member off to see a Warhol for visual excitement.[6]

[6] Recent case in point of interminable lingering on of message-loaded shots: 2001: A SPACE ODYSSEY.

Having talked at length about cutting rate and tempo, it might not be a bad idea to define these terms. Cutting rate is a simple, rather mathematical matter of the number of shots per unit of time or (viewed from the cutting table) per unit of length. The average theatrical film of the fifties had about two hundred cuts per hour, or about three visual beats every minute. That cutting rate has increased only very slightly in the past fifteen years. Action and adventure films tend to have higher rates (shorter shots, or more cuts per minute) than have romances and musicals. And documentaries tend to have higher rates than fiction films in general, although the interview *cinéma vérité* documentary is a notable exception.

No one really cares about cutting rate, except as one of the elements of cutting tempo. Editors seek, and audiences are affected by, cutting tempo, which might be defined as the *felt* cutting rate. A series of shots of similar and matched internal action will have a lower cutting tempo than would a series of shots of the same lengths, but of unrelated action. Shots connected by the softer editorial devices (fades, focus-throughs, dissolves) will produce lower tempos. Typically, a group of close-ups create higher tempo than do a series of wide shots cut together at the same rate.

On the other hand, shots that have high internal action, histrionic pyrotechnics, camera movements, changes in lighting, or elements that intersect and interrupt the field of view produce higher tempos. It is also true that shots covering significant plot revelations, or moments of danger and fear, or confused and uncertain events, tend to produce higher cutting tempos.

All of this is fairly obvious, and the reader can expand on the instances given from his own background of film viewing. A little more subtle is the problem of *relative tempo*.

Because the audience rather quickly adapts itself to the special cosmos of any given film, cutting tempos must be viewed in relative terms. In a film with an overall high tempo,

a climax scene must be very high (or very low) in tempo to give it special significance. Again, if the audience becomes familiar with the locale, the situation, or the characters, a cutting tempo that would have been high enough at the beginning of the film would be noticeably too slow later on.[7]

We mentioned earlier that the cutting rate of modern films is not much higher than that of films of fifteen years ago. What we have here are the countervitiating effects of younger and European styles, on the one hand, and the wide screen with its lower cutting rates on the other. With the exception of the Swedish, European films seem so much faster moving than a measurement of their cutting rates would seem to suggest. The effect being felt here is contrast between the relative tempos of the various sequences. Taking Godard's BREATHLESS as an example the reader is likely to have seen, we have passages with very high cutting rates intermingled with passages that cover long actions in single shots (recall the complicated virtuoso dolly and counter-dolly at the TWA ticket counter). The average cutting rate for the film as a whole may not be much higher than that of more conventional films, but

[7] It is not possible to do much that is valid in the way of experimentation in cutting tempo because the isolated passage is so unlike that same passage viewed in the context of the film. But we have toyed with experiments to give support to certain basic insights into tempo. We have shown audiences films especially cut, then asked which shots were longest, which shortest, etc. This much is clear: If a group of shots of similar data are cut together at a perfectly regular rate, the audience will sense that the later shots are longer than the early ones. What happens, we guess, is that their limens of recognition become progressively lower and they have, in part, exhausted their cognitive interaction with the shot, so they feel done with it sooner. What almost everyone means by a "long" shot is that the shot lasts longer than one's need for it or interest in it does.

We were able to produce an audience reaction of regular, even tempo by reducing the length of each successive shot. The amount of the reduction followed no formula we could see.

One other result of these experiments: When a shot of completely new and unexpected content was introduced into a string of shots of similar data, it had to be considerably longer to produce the feeling of enduring on the screen for the same length of time.

the contrast between the relative tempos of the various segments produces a total effect of much higher tempo.

We have mentioned that wide-screen films have fewer shots than those made for conventional screens. However, the greater amount of information to be absorbed within the frame tends to bring the cutting tempo of these films very close to that of the three-by-four format.

Thus far we have concerned ourselves only with the tempo of the cutting. There is also the impact of the cut—that which we call "cutting volume." Cutting rate, internal action, repetition of locale and event, camera movement, intersecting data, and other such things determine the cutting tempo—the number of felt beats per minute. The strength or volume of these pulses is another matter. Cuts between shots of saliently different compositions are palpable "loud" cuts, as are cuts to different locales, different color accents, different histrionic moods. The cut that leaves the action before it is comfortably resolved and plunges into another event is louder than one that slips gently from resolution to beginning—this is a kind of logical volume. The experienced and creative cutter (not always the same being, sadly) can use this tool of cutting volume to good effect to mute or accent his cutting rate and, by extension, his cutting tempo. By way of example of cutting volume: One of the many differences between the films of Godard and those of Truffaut is that Godard has a penchant for the loud cut—the high volume visual tempo.

The interrelationship of music and dialogue in cutting tempo is a complicated matter, presenting special problems for the editor. It is obvious and true that the lengthy shot can be lifted in tempo by the accompaniment of high-tempo sound. However, it is seldom successful to try to save a turgid passage by running fast music with it. My own attempts to do this have been telling failures. What seems to happen is that the exciting music serves only to contrast with and accent the slow cutting rate. Indeed, any kind of doctoring of cutting tempo

(short of going back and recutting the footage) tends only to aggravate the problem.

The correct approach to cutting tempo is prophylactic, not therapeutic. But, as in all editing, once a bad element is diagnosed, the response must be surgical, not homeopathic.

The key creators in any film are the writer, director, cameraman, sound man, and the editor. The editor shares with the sound man the sad distinction of being forgotten and undervalued, while the fellow who writes a catchy song or the man who unearths the tax write-off money receives considerable public attention. But anyone who looks at the delicate and powerful tools of narrative continuity, match action, compositional back-cutting, forced logic cutting, cause and effect organization, eye-guiding, thrust control, cutting rate and tempo will recognize that the gifted editor contributes more to a film than the chucking out of overexposed shots and the removal of claps without loss of synchronization.

Montage

The goal of editing is to order and enhance content; the goal of montage is to create content. Of the many literary terms that have been yoked to the film languages, the concepts of trope and metaphor are least alien, and these apply best to the montage effect.

Montage is the arrangement in time of the film's linguistic elements so that they interact to create a total message that is greater than, or different from, the sum of the messages considered separately. The time relationships between two or more elements may be either juxtapositional or simultaneous, and the elements may be image to image, sound to sound, or image to sound.

It is perfectly tenable to suggest that the content created through montage is the most important, or at least the most filmic, expression of the language. Montage separates film from narrative, drama, painting, music, and the other artistic media that film may incorporate. Without montage, film might be little more than a convenient carrier for these other art forms.

When one shot follows another in time, the second is unavoidably seen in terms of the first, and the first is unavoidably remembered in terms of the second. This effect occurs even if the shots are not related in any linear, incremental laying-out of the plot (in which case, the second shot might not even make much sense without the first). Such content as derives from this interrelation, but does not exist in either of the shots alone, is called montage.

So the term "montage" is used two ways: as a name for a technique for creating content, and as a label for that content.

As viewed by the Russian director and theorist Eisenstein, montage is the inevitable result of the combination (collision) of *any* two shots. But as the term is most often used by film makers (in England and the United States, at least) it refers to substantive montage only.

To take an example of montage at its most formal (content empty) level, imagine a black screen. The viewer would read, if anything, "blackness." If he were conditioned to a symbol set, and if he were imaginative, he might also read some elemental message, like "death." Now imagine a white screen. The viewer might read "whiteness," and he might extend that to some basic symbol, such as "death." (Here we have Freud, Fromm, and others against patterns in Western culture and are producing a seeming paradox.)

But, given a screen that is black *then* white, the viewer would be able to read "black-and-white," a polar concept, a yin-yang principle, the possibility of alternatives and gradations that did not reside in either the black or the white

separately considered.[8] These additional content possibilities are the effect of montage.

Functionally, montage is seen to operate in several ways, but within just two broad headings: substantive (or additive) montage, and conditional montage. Under the latter rubric there are three subdivisions: predispositional montage, the filmic symbol, and contrast.

SUBSTANTIVE MONTAGE

Substantive montage might be described as a series of shots combining to produce either a nounal concept or a total effect that can be encoded in one or more nouns. For example, a substantive montage built of shot after shot of people whispering in the ears of neighbors, talking over back fences, or on telephones might amount to the nounal concept "rumor." This effect would be described as a montage of rumor.

You will note that all of the actions that were the building blocks for the noun "rumor" were verblike in nature, involving action and doing. It is not odd, therefore, that when a montage is qualified it is usually given a verbal adjective, as in "spreading rumor" or "declining business."

As we have said, it is this kind of substantive effect—the production of a lengthy or difficult event by collapsing time and displaying its fragments—that Hollywood and London writers mean when they call for a "montage."

For the analyst, the substantive montage presents a special problem: quantification. In such a passage as that described above, there were many shots of people talking, leading to one final concept of rumor. If the analyst relied on rigid quantification, he would have many "talkings" and only one "rumor."

[8] Of course, the viewer might also be driven out of the room with visual nausea after being subjected to such an "experimental" film of stroboscopic effects.

And yet it is patent that both the film maker and the viewer would agree that the passage had rather a lot to do with "rumor" and rather a little to do with "talking."

Until a better method of quantification for the montage appears, it seems fairly accurate to reverse frequency count between the elements of the montage and its terminal effect, if one wants to place an appropriate significance on the passage. Thus, if seven shots of people talking were combined to create one substantive montage of rumor, a value of seven might be given to the instance of "rumor" and a value of one to the instance of "talking."

Conditional Montage

Conditional montage constitutes the other large branch of montage relationships. Quite simply, conditional montage could be defined as all other content productions based on juxtaposition and simultaneity than the substantive montage—although it must be remembered that, even in the substantive montage, certain conditional relationships exist between the various increments that make up the terminal noun.

We call them conditional montages because the extra content seems to be an effect of the conditioning of the audience member through exposure to the first shot, under the terms of which he views the second.

Three kinds of conditioning have been observed: the predispositioning of the audience member, the creation of the filmic symbol, and effect through contrast.

Predispositional Montage

This is the most common and effective of all montage. Functionally, it operates by causing the audience member to re-

ceive the information of a later message in a way toward which he has been predisposed by an earlier message. It is important to separate the effects of predispositional conditioning from the concept of simple, linear, logical narrative.

An example of each would help to clarify this: If we had two shots, one showing a little cottage, then a dissolve to an elderly man reading a book in a den, it is likely that an audience member would view the combination thus: There is a cottage, and within it is a man reading a book. But if the shots were reversed—if first we saw an elderly man reading a book, then we dissolved to a shot of a cottage, it is likely that the audience member would read: There is a man reading a book—about a cottage. Obviously, the difference between the two passages resides in the order in which they are seen. But this is not a montage effect; it is a matter of what we have already described as cause and effect continuity. The viewer has related the shots through logic in a meaningful way.

In the case of a predispositional montage, the content produced through the juxtaposing of two shots is perceptual, not intellectual, and occurs subtly and instantaneously with the moment of perception, rather than progressively in result of logical manipulation of the visual data.

An illustrative case of predispositional conditioning through montage is the well-known experiment of Lev Kuleshov as reported by Pudovkin and others. Kuleshov inserted an expressionless close-up of the face of the actor Mozhukhin after the following shots: a bowl of soup, an elderly woman lying in a coffin, and a child playing with a toy. The audience to which the reel was shown praised the actor's interpretations. In the one case they saw hunger; in the next, grief; in the last, joy and contentment.

Now what happened? In no logical sense does a bowl of soup plus an expressionless close-up equal hunger. But the shot of the soup predisposed the audience to view hunger in whatever expression followed. And so with the other combinations.

Given the conditions of the first shot (or preceding sequence, music, or montage), the viewer is predisposed, on a perceptual, prelogical level, to read the second shot in a biased way—and this is predispositional montage.

THE FILMIC SYMBOL

Another element of the film language created through montage is the filmic symbol.

It is understood that the film maker can avail himself of both cultural and literary symbols without having to establish them through montage. A shot of the flag, or of the cross, will carry its traditional cultural symbolic value; and literary idioms may be used without any special preparation of the viewer, such as dawn for the start of a new life, or the plucking of a flower for loss of virginity.

But beyond this rummaging about in the trash can of literature, the film maker is free to create and manipulate his own symbols through montage. Take the classic example of a filmic symbol created through montage found in the Pudovkin sequence in which the inactivity of the oppressed masses is identified with a frozen river (MOTHER, 1925). As the wrath of the rabble rises, we are shown the river thawing. As they pour into the streets to avenge themselves, we cut to the river breaking up, huge chunks of ice churning destructively downstream.

Now there is neither a cultural nor literary symbol that has established that rivers and ice represent mass revolution; but, through countercutting and montage, Pudovkin created a clear and effective symbol for *his* film.

Once the symbol has been identified with the event symbolized, it may be taken to be an incident of the event—an incident having higher impact than the event itself. We must assume that the symbolized event has higher impact than its photographed counterpart because, if it did not, the time and

effort expended in establishing the symbol would be lost. Indeed, early in the sequence, while the event and the symbol are still being married through repeated juxtaposition, there is a loss of communicative efficiency that must be made up for by the power and value of the symbol, if indeed that symbol has any function other than to demonstrate the film maker's creative imagination.

So we have the valid symbol both communicating vigorously once it is established and wasting communicative opportunity while it is being cross-identified with the event it symbolizes. These two effects tend to weaken one another, and the symbolized passage will end with saying no more and no better that which the same amount of time and care could have said without symbolism with its concomitant risk of obscurity—unless, of course, the symbol is necessary.

How does a filmic symbol get to be necessary? In two ways: It may be the only way in which certain messages can be presented, or it may be the most expedient way to transfer certain content. The symbol would be the only way to communicate if the message were outside the normal language of images and sounds, such as subtle changes in feelings and attitudes. It would be the most expedient communication if the literal presentation would take too much time and attention away from the main thrust of the film, such as a symbolic social rise of a character, the literal description of which might interfere with the flow of the film.

It will be noticed that I do not suggest the use of symbols to cover events and actions that are financially or technically too difficult to film literally. A film maker should design his film in terms of his external and internal assets, not in terms of his aspirations and daydreams.

Contrast

The primary effect of montage of contrast is intensification; the secondary effect is the production of polar concepts and potential continua. Clearly, the rich seem richer if their activities are intercut with images of the impoverished, and at the same time the poor seem poorer. Beyond this effect, there would also be an established continuum of wealth with its implication of many levels of economic condition that would not have been revealed if only images of the rich were shown. All of these effects are achieved because the audience has by one shot or passage been conditioned to view the next in a certain way, and therefore they are montage effects. In a long sequence dealing with the activities of the rich, the attitudes, surroundings, relative values, and trappings of wealth become common and idiomatic to the viewer, and the rich seem less so.[9]

Superimposition and Racket Cutting

Since montage is the content created through the juxtaposition of two images, this is an appropriate place to discuss the effects of images seen simultaneously. This includes superimposition, split screen, and the intercutting of single or double frames from two shots, an effect sometimes termed "racket cutting."

Technically, none of these effects are pure montage but content elements based on the relation between images.

[9] A historical case in point was the overdone white telephone penthouse setting of many movies of the depression. The filmgoer, seeing only wealth and little poverty, lost all sense of "wealth." This was the cosmos of the film world, not of the wealthy. And anyway, the best things in life were free—which as I recall just barely put them within our economic reach.

Superimposition is, operatively, the double exposure of the film. One of the images (the one with least light) will seem to be transparently imposed over the other. It would seem that the two images would enjoy a very close interrelationship, seen as they are simultaneously within a single described space. But actually, the device has been used only occasionally and is read by the film literate in only a few habituated ways. One general meaning of the superimposition deals with the supernatural—ghosts, spirits, or the like. The other (somewhat old-fashioned) would read: "The character is thinking about. . . ." In every case the device is not common to the visual experience of the viewer and is, therefore, artificial and mechanical.

Split-screen effects are produced through matte operations in the laboratory and place one image above or beside another. Once a popular element of the language, split screens fell into disuse, but have emerged again, first in titling and now in the main body of the film. Like superimpositions, they remain palpably artificial and mechanical because they lack realistic counterparts in our visual experience (at least while sober and not on drugs). The split screen has recently been used effectively to carry several merging lines of action in cases when the separate revelation of each series of actions would have been redundant and costly of time, so that we can look forward to more extensive exercise of this perfectly valid tool.

As an element of montage with predicted and desirable content emerging from an interaction of the various shots, the split screen leaves something to be desired. It is not true that the viewer watches all the shattered images at the same time; he views one or another, his eye wandering uncontrolled, the "cutting rate" within his own volition. Certain general effects can be relied on, like a sense of intense action or impending collision of the separate actions, but the director had best not try to make a very concise or significant point with a tool so much out of his control.

Racket cutting is a near-relative of superimposition. The exchange from shot to shot is made every one twenty-fourth or one-twelfth of a second and (with the average human retention of image on the retina being one-tenth of a second) it has the effect of a kind of epileptic superimposition. A classic example of the impact possible with racket cutting would be PACIFIC 231 (Mitry–Honegger, 1949). The device has largely been limited to experimental films and has not become an idiom of the film language. Functionally, it has much the same effect as the superimposition, but it adds a feeling of excitement or chaos.

Sound in Montage

Thus far montage has been looked at in terms of image related to image. Image also relates to sound, and sound to sound.

All of the principles of image-to-image montage can be applied to sound-to-sound montage. Single sounds can be built up substantively to create a total effect, a single noun. One sound can predispose the audience member to receive the next in a certain way. Sounds can be symbols (the leitmotif being a classic example). And the effect of one sound can be altered through contrast with another (consider the ringing emptiness of presence that follows a gunshot).

Sound-to-sound montage has an important effect on the visual cut; it can either strengthen or loosen the normal montage bond between any two shots. If the sound (usually music or background sound) continues through the visual cut, it tends to bind the images closer together, intensifying whatever montage relationships are weakened (except, obviously, in the case of montage of contrast). The degree to which the images are wedged apart is a function of the difference (in volume, tempo, instrumentalization, or other characteristics) between

the two musical backgrounds. These binding or loosening effects were termed "vertical montage" by Eisenstein.

One instance of sound-to-image montage has already been discussed when we spoke of satiric music. It will be remembered that the images were made to be read in a certain way (in reverse, as it were) because of the simultaneous and contradictory message of the music.

The leitmotif is an interesting case of sound-to-image montage that really produces image-to-image montage. If the music identified with one character, event, or emotion is imposed on a visual message of some other character, event, or emotion, we have in effect an internal, ghostly superimposition.

Music can influence the message of the visuals in a variety of ways, so numerous and individual that it is difficult to discuss them without reference to a particular film—and that we leave to the critics who may choose to establish a mechanical and linguistic basis for their analyses and responses. In general it may be said that music tends to weave its mood (if that word is understood to include crisp pace and gaiety, as well as more somber implications) through the shot or sequence with which it works.

6

The Burdens of Film

. . . the burden is derrydown, come derrydown, heave-ho!
Sea chantey

A few years ago a panel of judges decided to award prizes
to the least tedious and trivial paintings by a group of mid-
western artists. The aesthetic Right had produced a lot of
prairies and little blue flowers of ineffable delicacy. The Left
seemed to have ingested tubes of pigment and urinated onto the
canvas, plasterboard, scraps of tin, or crumpled corrugated
boxes. Between these poles of frigidity and abandon ranged a
mass of seminarrative paintings showing *tranches de vie* hewn
from the daily rounds of local pig farmers. There were the
usual number of glowering crucifixions intermingled with
scenes of home life and family outings that would have made
Norman Rockwell drool.

But the awards had to be got rid of somehow, and the piece
that finally took first prize was a sociological narrative dealing
with the race problem. The canvas was crowded with Negroid
faces colored white, and Caucasian faces colored brown, and
there were fragments of posters proclaiming the need for
equality. My fellow adjudicators, honorably motivated by
humanistic impulse, read this as a worthy painting on the
basis of theme. The work, however, had little to recommend

it from the standpoint of color, composition, line, thrust, and other nonnarrative considerations.

More than than any other of the major media, the film possesses the advantages and the burdens of dual function. Not only is it a mode of expression with its own linguistic qualities, problems, and delights, but it is also a popular recording and broadcasting vehicle for other languages: literature, drama, the social essay, opera, the dance, musical revue, teaching, and the less lively visual arts. It is only natural, therefore, that the film suffers the problem of having its proper values commingled and confused with the values of the burdens it carries. Most critics—typically writers dealing with film, rather than film makers who write—speak of the burdens when they praise or attack a film's theme, acting, psychological frankness, sociological accuracy, plot structures, music, symbolism, and the other nonfilmic elements of the total viewing experience.

There is nothing wrong with this kind of criticism—except that it obscures criticism of the film per se—just as there is nothing wrong with the film being used to record and broadcast messages from the other media codes. A trip to Africa is worth the cost of admission, as is a venture into Fellini's preoccupation with his involute psyche, or eavesdropping on Bergman's working out of his problems about God and sex, or watching a recreation of the Fall of Troy, or enjoying Duke Wayne's feline walk, or seeing the *Ballet russe*. And many significant insights into all kinds of things can be offered by these critics who see and comment on everything in a film but the filmic things.

Nevertheless, one awaits the contributions of a critic who understands and deals with the language of the film, as well as with its burdens.

Thus far, we have treated of the film language in its pure form without reference to the various message structures that can be carried by it. Now we shall examine some of the histrionic and literary burdens of the film. For clarity, we shall

discuss the writer and the director as though they were two separate beings—as more often than not they are—and some of our descriptions will require rethinking by the reader in the case of the *film d'autore,* in which the creative contributions of writing and direction flow from the same mind.

Histrionic Content

Despite the fact that the film form has no inherent need for the actor or for theater, it remains true that most modern films of wide reputation have used the professional actor as an instrument in the transfer of information and attitude. A film maker may be a master of most of the crafts needed to make a fine film; he may be sensitive to the situation he is attempting to investigate and to the plastic from which he is building his message without having any firm idea of how the actor accomplishes his tasks, or of just what these tasks are.[1] If such a film maker uses actors (professionals or not) without knowing enough of their peculiar virtues and weaknesses, he will produce a film that is weak to the extent that he is out of control, discounting, of course, his and the actors' instinct and good sense.

Even the documentary film maker who chooses to use real people who are amateur actors rather than real actors who are amateur, let's say, bankers, will find that he is putting his real man into the artificial circumstance of having to reproduce events and situations for the benefit of the unreal camera, lights, booms, and the rest of the impedimenta of film making. Even if he manages to work out his film so that he can shoot on location with available light, he will face the task of getting a kind of realism out of a subject who is working under the

[1] The opposite is also true, Mike Nichols is an example of a director of actors par excellence who is, one cannot help feeling, always a fraction out of control of his basic film plastic—usually to the detriment of the film.

unnatural conditions of—at least—repetition and loss of spontaneity. Some knowledge of the actor's work will help him guide his subject through the obstructions of artificial circumstances.

No attempt will be made here to capsulize the complicated techniques and qualities of the actor that the dramatic director should know or intuit. This has been done with limited success by Stanislavski, Boleslavski, Pudovkin, and others. But no description of the filmic burdens would be complete without a look at the basic elements of acting from the standpoint of their effect on content.

The film's histrionic indicators will be examined under three headings: Characterization, The Unit, and Residual Characterization. This last is included because no one has as yet looked into this quite important element of the language; therefore there are no other sources we can offer the reader.

CHARACTERIZATION

The words of a script, its setting, and its necessary bulk interpretations would be more or less the same with any actor and any director. What does differentiate one man's rendering of a film from the next man's is largely interpretation and characterization. The guiding force in this characterization may be either the director or the actor, but characterization ultimately resides in the actor, and it cannot exceed in quality the abilities of the actor.[2] It has been said earlier that the film is a child of realism. It is most important, therefore, that the message of the film adheres to the kind of realism that lets the viewer be-

[2] These abilities may be latent, and the actor may not be able to call them up without the aid of his director. Mifune Toshiro is a fine example of an actor of considerable latent ability who seems incapable of producing a valid performance without the midwifery of one director—Kurosawa.

lieve that something happened, is happening, or might happen more or less as it would happen in the real world, granted the special given circumstances and cosmos of the film. When a lay person is asked what he thinks makes for good acting, he usually responds by saying that the work must be believable. For the actor, this means that the character obeys the motives established in the script and acts always in terms of these motives. The scriptwriter designates what will happen; the director decides how it will happen; and the actor gives the event its necessary truth by attaching the action to its motive —he says why it will happen.

In modern acting (Stanislavskian, or 44th St. neo-Stanislavskian) the character is a complex of reactions, not an originator of stimuli. He does not act; he reacts—to the situation, to his background, to his psychological peculiarities, to other characters. For this reason the modern actor operates in the language of the film as an excellent indicator of the attitudes and values obtaining in the film cosmos and, if the film is to enjoy popular success, in the society in which the film is produced.

There is also no reason to assume that the exploiters of personality (Wayne, McQueen, Bardot, et al.) who always play their own (or carefully structured) personalities—as compared with actors who produce fresh characterizations for each film— are in any way less valid in the film, provided that the objectives and motives in the script parallel those of the actors.

For the analyst, characterization is better seen as a modifier of content than as a creator of it. The scriptwriter and the director will create the essential message, which will then be filtered through and interpreted by the actor. The special qualities of the humanization and particularization of the words and actions of the script that constitute the actor's task seem so much a part of the good dramatic film that most analysts and nearly all critics seem incapable of separating the work of the actor from that of the director and the writer.

THE UNIT

The unit is a division (in time, usually) of the total characterization that breaks it up into analyzable parts.

It is understood that each character in a realistic drama—both stage and film—has at least one motivating objective. What he does, how he does it, and why he does it are matters determined largely by this objective. It is for this reason that the scriptwriter would do well to emulate Ibsen and know the desires and motives of his characters well before he writes them. For the same reason, the director should work out the characters and their motives fluidly in advance of any other consideration in the fiction film.[3] ("Fluidly" because, if he constructs them rigidly, he loses the benefit of the actor's creative contribution to the film.)

These objectives are worked out in terms of motives (i.e., social, sexual, economic, or personal stimuli) to which the character reacts. The attitudes and values obtaining in a film are largely to be found in the patterns of motive that constitute characterization. And the good/bad measurement that critics attempt is often based on the degree to which the motive structures in a film seem to them to be appropriate to those in life and society, and on the degree to which the total characterization seems to represent a whole, recognizable person. For these reasons, it is unfortunate that few critics and no analysts have demonstrated any special knowledge of the histrionic principles on which so large a part of their work ought to be based.

An objective may be simple, or it may be highly complex; the character may or may not be able to define it, but the actor

[3] This working out of characterization may be done in concert with the actor, as Bergman does, capturing, analyzing, sometimes discarding the fresh, relatively unrehearsed reactions of the actors; or it may be heavily predicted and organized by the director prior to meeting the actor.

and the director must be able to do so, because the pursuit of this objective motivates the character through each of his actions and communications. The actor/character dual personality is a unique characteristic of drama. In the artistic task of creating a character, the actor is at one and the same time the sculptor and the clay.

Conflict is the core of good drama. Conflict worked out in terms of action (external action ultimately, but this may be internal action somehow externalized) is the core of any good dramatic film. This conflict occurs when each of two or more characters, acting in pursuit of his identified objectives, finds his path blocked by another character moving in pursuit of his objectives. The protagonist/antagonist structure so popular with those who prefer a simplified view of the world is one in which the viewer is called upon to prefer that one of the two characters accomplish his goal at the expense of the other. (Note: While the hero is always a human being, the antagonist may be depersonalized: it may be a social condition, or an indifferent world, or a virgin mountain.)

During this conflict we are expected to choose and identify with one of the two characters. Our choice is directed by the film maker in terms of objectives and methods. The "good guy" is differentiated from the "bad guy" not by any significant difference in the degree of determination with which he strives for his objectives and goals, but by the identity of his goals with those sought by the viewer. Once this protagonist structure has been established through the catholicity of the character's objective (or sometimes by so fragile a thing as the stardom of the actor), it might be enhanced by laudable, or at least, acceptable methods of earning it.[4]

[4] It is noteworthy that the protagonist's methods may be dubious indeed without his losing the sympathy of the viewer. In the climaxes of typical Westerns, the hero spills more blood more efficiently than the villains ever did. The difference lies in the fact that the villains threatened little nice people, while the hero skillfully ventilates big ugly people.

It is in part because of this principle of protagonist establishment that the content analyst dares to propose that the attitudes and values found in the hero of a successful film reflect those existing in the society in which the film was shown (not necessarily those in the society in which it was made).

What has thus far been called the objective is, in the argot of the Stanislavskian actor, the "superobjective." It is the greater, ultimate goal of the character. If this superobjective were, say, escape, it would probably be broken down into a constellation of related, contributing simple objectives (the catching of a train, hiding, a combat, etc.). But the simple objectives must always be played in terms of the superobjective. For example, the character who is escaping from something, and who has that escape as his superobjective, might very well feel hungry at a given moment. His hunger and the actions he performs to rid himself of it may not contribute directly to his superobjective: escape. In this case, the dominating terms of the escape might decide how he ate, where he ate, or even when he ate.

Each of the simple objectives that make up the superobjective constitutes a *unit.* More precisely, the unit is all of the uninterrupted time that a single character is pursuing a simple and defined objective that ultimately contributes to the accomplishment of his superobjective. Units are punctuated by what is called a "beat," and recognition of the beat exchange from unit to unit is not only necessary to the director and the actor, it is also vital to the analyst or critic who wants to understand the histrionic content of a film and single out moments for praise or condemnation. The beat (sometimes called the "beat adjustment") is the overt manifestation of an internal exchange of units. When a unit has been accomplished, or surrendered, or pursued as far as it can be in the circumstance, the character turns his attention to the accomplishment of the next unit—always in an ongoing flow toward his superobjective. The instant of this change of concentration must have

some outwardly manifest (although inwardly generated) action or behavior.

We stress this matter of the beat because an understanding of it helps the film maker to comprehend and conduct the work of the actor. We must also consider that criticism of acting has always been a democratic activity. The audience member who wouldn't dare express his opinion of the cutting of the film, the composition of a shot, the arrangement of the music, bears his burden of technical ignorance lightly when it comes to acting, and he is not a bit abashed to proclaim his opinion as though it were based on knowledge and experience of this most complicated craft. Unfortunately, many directors and most critics are similarly inclined.[5]

As a rule, when an actor is doing poorly, or when he tells the director that he "can't do" or "doesn't feel" a certain behavior, it is not the unit that disturbs him, but the beat. An actor can do anything—laugh, cry, be angry—he can pursue any unit. His grasp of scenic truth slips, however, it he is asked to move from unit to unit—to cry *then* laugh—without an adequate and justified beat adjustment understood in terms of motivation and characterization. If the director fails to pinpoint and clarify the moment and character of the beat, the actor will either force (overact) the units, or he will shatter character in his attempt to cover each unit with one fragment of personality. Both are called bad acting, when in fact they are bad directing.

[5] Case in point: Since shortly after her death, Marilyn Monroe has been offered by many writers as a typical and tragic example of the Outsider, the *enfant perdue,* the fragile human numbed and confused by the glare of the kliegs. And she may well have been this. But unfortunately this human concern has bled over into criticisms of her acting, and now many people who should know better are managing, through dint of creative memory, to find histrionic value in her petulant posturing. One may be a significant and tragic personality without being a good actor. Miss Monroe was every bit as shallow and dull as we thought she was at the time. The artificial redemption of her as an actress is in no way necessary to a recognition of her as a reflection of the current social threat of moral poverty and lack of inner resource and purpose.

By the way, it is not uncommon for scriptwriters to fail to give the character a beat adjustment, so the director must fill the gap by inventing a bit of "secondary narrative" within the restrictions of the characterization. In truth, there is almost no other way to make believable and palatable the phony trumpet characters in "message" films and dramas.

Discounting bad taste, technical incompetence, and insensitivity, the most common cause of overacting is overbeating. The volcanic, emoting female stars of the twenties and thirties were particularly guilty of this effect (although not of this practice, since they never knew what a beat was). The decision to answer a telephone, to say yes to a dinner date, to open a door, was preceded by the kind of major internal communication that should accompany a full beat exchange. Pregnant pauses abounded, as did furrowed brows and twisted handkerchiefs. The director and the actor must recognize the difference between change of tactic or accommodation to circumstance, on the one hand, and the significant exchange of unit objectives, on the other.

Not only is a knowledge of these most basic principles of acting vital to the director and the scriptwriter, but it is useful for the discerning filmgoer. Usually, when a viewer says that he likes this actor or that, he means that he understands, identifies with, and admires him—that he finds either the characterization or the personal exploitation to be both believable and significant. What makes a character believable is his close adherence to known and demonstrated objectives and his ability to make clean and motivated beat adjustments that indicate to the viewer that a new objective is being considered.

As each unit is accomplished, the plot line is advanced. The manner in which the character goes about accomplishing his unit task—or about attempting to accomplish it—describes and reveals him. As the audience member comes to understand the character and his accomplishments and failures, he can comprehend the particular attitude–value cosmos of the film.

He comes to know that persons holding such and such values fare well, while persons holding other values or having other characteristics fare poorly, in the special world of this particular film.

In the well-made film it is common that the histrionic element of the unit and the filmic element of the sequence begin and end simultaneously, and this cooperation of form and content is one of the film's more effective message structures.

RESIDUAL CHARACTERIZATION

Residual characterization is made up of the elements of character that the actor brings to the screen before, and extra to, his histrionic task. Although a relatively unimportant aspect of stage drama, residual characterization is a most significant matter in the film where personalities and stars are more important than actors.

Residual characterization is a facet of what Stanislavski called "personal exploitation" and is composed of a complex of the role the actor has previously played, what the audience member knows (or imagines he knows) of the actor's personal life, and other purposeful or inadvertent communications to the audience member concerning, not the character, but the actor.

Despite the fact that residual characterization has received no attention from analysts and critics, it is simply untrue that a John Wayne appears at the first moment of a film without carrying along a great web of anticipated and remembered characterization.

For many people, what happens to a John Wayne happens to the best of men, to the most of men, to the audience member. An actor carrying to the screen a residual characterization of the villain type can go down to defeat without much having implied in the way of general social fear or protest. But send

Gary Cooper to defeat (or near-defeat) at the hands of an in-different society, and the audience feels the need for com-munity responsibility indeed.

To be sure, residual characterization operates as an element of the film language only in the professional feature film. The documentary, the educational film, and the experimental film have none of the benefits and drawbacks of this rigid channel of communication, save for the fragile advantages of cashing in on Hollywood-established "types" or the dangerous alternative of using social or ethnic stereotypes.

The line dividing residual characterization from personal ex-ploitation is thin; indeed, it might better be described as a band of twilight gradations. In the evaluation of film actors, the separation of those who characterize from those who ex-ploit their own personalities is descriptive, not critical. There are good and bad actors at both extremes. It is perhaps un-fortunate that the word "exploitation" carries the pejorative connotations of imperial expansion. The differences in shading between these two poles might best be described by taking the examples of three well-known and widely admired film per-sonalities: Sir Alec Guiness, Rod Steiger, and Jerry Lewis.

Alec Guiness is the characterizer without peer. In person, he is a featureless, almost bland man whose face and form equip him with the ideal plastic for creating total characters on the screen. In role after role he has presented audiences with subtle and novel personalities, none of whom he is in life, but each of whom is eminently believable.

Jerry Lewis, who enjoys vast critical popularity in France and great public following the world over, is an example of the personal exploiter par excellence. Through film after film he has displayed the same chaotic overreaction to stimuli, the same frenetic physical rhythms, the same overtones of Chap-linesque bitter-sweet response to an indifferent world, the same optimism in the face of great odds, not the smallest factor in which is his own social ineptness. No one remembers the names

of the characters he plays, because these are not characterizations, they are only opportunities to display the qualities of personality that he has developed and that the audience enjoys.

Rod Steiger is an actor of considerable force, and one who is enjoying just now a much deserved recognition. He lies somewhere between the extremes of Guiness and Lewis. To be sure, he adopts and perfects fresh characterizations for each role, but certain qualities are impressed deeply into each man he represents. Any character played by Steiger will be lent his special qualities of inner tension and communicative constriction. The character will always ride at the dangerous edge of social control. His grip on his reactions will always be fragile. His responses will always be passionate and repressed.

The many graduations between characterization and personal exploitation describe, not so much the value of the actor, but the roles in which he is likely to do well and the methods in which the director should work with him.

Literary Content

Heretofore we have given our attention to the perceptible, first-level code structures of the film language. But as the total effect of these basic elements of the language are collected, remembered, mixed, abstracted, and generalized, one comes to statements and reports on the whole effect. These general statements cover large amounts of content in abbreviated, greatly subjective terms. We use the literary concepts of "theme" and "plot" to designate this mass of superimposed attitudinal and factual data.

Strictly speaking, there are no themes, no plots in a film— there are only sounds and images. However, the fact that the film is not a literary form need not prevent the audience member, the critic, or the film maker from reporting his observations

in this borrowed form. For one thing, indicators of theme and plot are available to the sensitive and thoughtful viewer without the complicated and time-consuming process necessary to analyze film content on its primary level. For another, one can speak of theme and plot without having to know much about film, it is only necessary to know what you like.

Two quite different concepts are involved in the terms "theme" and "plot." In one frame of reference, they are the guiding principles in terms of which the film maker collects and organizes his sounds and images. In another, they are the collective fictions in terms of which the viewer or critic comments on the total impact of these sounds and images. Since critics, analysts, and audience members must work with the end product of the film message, they do not use exactly the same definitions of these two terms as the writer or director might. Lajos Egri presents the writer's point of view fairly typically in his *Art of Dramatic Writing*.[6] He identifies "theme" with "premise," and he views the theme of a play in a sort of noun–transitive verb–noun construction, as when he tells us that the premise of *Romeo and Juliet* is "great love defies even death," or that the premise of *Dead End* is "poverty encourages crime." This is obviously a thoughtful and useful description of theme, and one much needed, since the term is so vaguely used by critics that it might be taken to mean anything from general plot line to random thoughts stirred up in result of viewing a film.[7]

But Egri's definition is too limited for the film maker. In the complex tapestry of a film, not all of the noun concepts (such as love, death, poverty, crime) are worked out in such neat transitive relationships. A story of love and death might be set against a background of poverty and, although the threads of love and death might be interwoven in some transitive (leads to) way,

[6] New York: Simon & Schuster, Inc., 1960.
[7] Indeed these thoughts and feelings might even be the result of a recent scrap with a lover.

the thread of poverty might simply be underlaid so as to under-score, complement, contrast with or focus attention on the major themes. And yet, "poverty" would clearly have been a theme in the film. One finds in films many themes important enough to deserve mention and thought, but not worked out transitively in the story line.

There are two concepts here (usually indifferently lumped together as "theme") that require separation. It might be best to use Egri's term "premise" when speaking of a transitive, more or less inevitable relationship between two substantive concepts. And the term "theme" might be reserved for reference to any pervading, influencing, reinforcing, or contrasting nounal concept that does not necessarily interrelate with other concepts in the working out of the plot.

Granted then the existence of premises and themes, it becomes necessary to work out a set of events and characters to transfer these abstractions to the audience member. This is done through *story* and *plot*.

Again we have the confusion of two terms, unfortunately used interchangeably, denoting very different concepts.

In the story, events happen sequentially; the chronology of happenings deciding their order of presentation. In the plot, the story line is advanced through cause and effect. Of a story one says that thus and so happened, *then* thus and so happened. Of the plot one says that thus and so happened, *therefore* thus and so happened.

Obviously, the plot lends an inevitability to the outcome of the tale and gives a kind of universality of probability to the themes and premises, moving their import out of the film context and into the context of the viewer. In the story, the implications of inevitability and catholicity are slight.

Not all films are heavily plotted, and some (biographies, documentaries, and experimental films) are practically un-plotted. But when plot does appear, bringing with it its strong if/then implications, the film is likely to be successful to the

extent that its themes reflect those in the society in which it is shown.

Unplotted history (or story) is little capable of reflecting the fears and value structures of the mass of a society, being, as it is, the product of the imagination and experience of one artist —one outsider. Story line is best viewed as the framework on which content indicators are arranged, although a careful study of the climax structure of the story line and of the arrangement of elements of the film language on this structure will help the analyst to give proper weight to the themes within the film.

The use of *source material* in the film language is largely limited to the critic and the content analyst, although an understanding of it is to the film maker's advantage. The source upon which a film is based is no part of the essential filmic communication; but some significant statements can be made about the film maker's purposes and his society's attitudes by studying the *differences* between the source material and the film. One may assume that a change in plot, setting, character, or incident between a novel and its film version indicates some vision of the film maker, if one is satisfied that the changes were not the natural result of a change in medium and in native code structures. To some degree, similarities between source and film are also meaningful in that one may assume that this or that theme or incident was transferred intact because it was significant to the world of the film maker as well as to the world of the creator of the source. But again, the creation of the theme or incident was the work of some artist other than the film maker, and the use of it may reflect nothing more than fiscal expediency or imaginative paucity. When, however, events and characters are altered by the film maker, and this alteration is clearly not a matter of expediency (that is, when the change is more difficult to accomplish in the film form than adherence to the original would have been), then the critic is free to sup-

pose that the change was in some way significant to the society in which the film was made.

Above all, it must be realized that no really valid criticism of a film can be based on the degree to which it adhered to the original. It is perfectly proper for the film maker to treat the source material in any way that will produce a good film, be that line-by-line repetition, use only of the characters and settings, or use only of the title as a means of assuring his backers of fiscal return.

THE BURDEN OF MEANING

We recognize vast differences between the films of fifteen years ago and those of today. In the experimental mode, painting and scratching on film have been replaced by single framing of scattered visual material and by expanded visions of simple events. In documentary, the social-set piece of the British school has been eclipsed by the human-centered films of Pennybaker (single personality) and Marker (mass hero). And the narrative feature film has begun to abandon the fluff (Doris Day) and grunt (Brando) films of the past decade for the highly literary styles of Bergman, Antonioni, and Resnais.

Most noticeable of all the changes, however, has been the shift of roles between artist and audience member in responsibilities for that which we call meaning. In a relatively few years film has undergone a geometric progression of change since it was freed by television from the task of sponging up excess mass leisure and forced by the competition of television to produce offerings that would appeal to the audience member who stood, aesthetically, beyond the range of the cyclopean mesmerizer. And those who have not kept abreast with the changes in objectives and linguistics find many modern films to be "meaningless." When these bypassed souls stagger away from 8½ or L'ANNEE DERNIERE A MARIENBAD or JE T'AIME, JE

T'AIME believing that either they have lost their minds or the film is meaningless, they are nearer the truth than they realize. In a way of speaking, modern films are meaningless. At least, they are tending away from traditional views of the relation between the artistic communication and "meaning"—as are modern verse, modern painting, and modern literature.

The more traditional view suggested the existence of a vast body of something called experience. Experience embraced everything that happened to you, and all dreams, and all imaginings, and all memories and intuitions. Both the artist and the audience member had some of this experience, although it was assumed that the artist's experience was deeper, or wider, or in some other way more precious than that of the mere audience member. The artist was also supposed to have the technical skills necessary to organize his experience into useful, or entertaining, or up-lifting, or even instructive patterns that guided the audience member through vicarious participation in the artist's experience. The work of art was viewed as a kind of experience revisited, rearranged, reordered in terms of the tools and limits of the medium and with the object of conducting the viewer through the polished experiences of the artist. These organizations of experience followed logical, spatial, temporal, or narrative patterns that made them easy to remember and possible to predict—and this organization was called "meaning." A novel or a film meant something—something that the audience member could use or discuss or feel he understood without great effort on his part.

The burden of meaning was on the artist.

There is now a trend to make a film, painting, or novel an experience in itself. The artist concerns himself less with the classic organization of experience into meaning and more with the generation of novel and life-expanding experience produced at the moment of the viewing or reading. And the audience member has the task of blending this new experience with his other experiences, his imagination, his vision, and making of it

what is useful and exciting to him. If the audience member is possessed of the Teutonic cast of mind that rejects the unordered and the untidy, he will resist his new role as the creator of meaning by labeling the communication "meaningless." But this appeal to the viewer to collaborate in the sublimination of meaning out of experience links nicely with the phenomenological concept that the communication projects a certain distance from the event, at which point it is intercepted by the viewer's posited anticipations and needs, and it is at the collision of these relatively independent gestalts that "meaning" crystallizes.

The burden of meaning has been shifted to the audience member. The artist who is capable of generating the most deeply stacked, most multifaceted, most universal, and least common of experiences is the better man, where once it was the artist who was capable of organizing his experience into compact and evocative forms who had the world's praise.

The audience member is now called upon to participate in the creative venture. And this creative format is the most democratic of all, embracing multimedia presentations, "happenings," automatic painting, and almost any event that admits of participation and excitation. Some of the scholarly resistance to this shift in the burden of meaning is based upon spiritual inelasticity, but the more cultured gainsayers oppose this concept of art and meaning, not in denial of its potential and impact, but with the realization that the door to Art has been thrown open to Emperors in all states of sartorial neglect.

7

The Nonlinguistic Film

Just as the print medium has certain broad modes of expression—the novel, the essay, the advertisement, verse—each with its own goals, formal properties, and values, so film content can be broken down into broad modes: the narrative, the persuasive, the informational, the record, and the *film pur*.[1] Film functions to teach, to convince, to preserve, to entertain, to exalt the senses, and to fill vacant time. It is both art and aspirin, hero and heroin.

In film, the persuasive mode of expression spreads widely from Leni Riefenstahl's oblique and terribly effective promotion of Nazi ideology through to television commercials prompting the viewer to use deodorant. Many of the finest films of this mode have been hybrids between persuasion and record, like the grand social documentaries of Grierson and his team of associates.

The record–information mode typically produces arid viewing experiences that have value only to the extent to which the

[1] The term *film pur* has been chosen from among the available synonyms. "Experimental film" is too general. One may experiment within any of the filmic modes; and many *films purs* make no attempt to develop new and theoretical processes. "Art film" is similarly loose-fitting. The term has been borrowed to cover the titillative offerings of the midcity "scat" houses. And, in any case, reserving the aegis of "art" for this one mode would be an abuse to the narrative arts in film.

viewer is personally interested in the event. The mode becomes filmically valid only when it is designed to work as persuasion through information, as in the documents of living conditions in poverty zones; or when it is blended with the *film pur,* as in the work of Cavalcanti, Flaherty, or Mitry.

A yet more complicated olio of modes would be a film like THE RIVER in which Lorentz combined the record and the *film pur* with persuasion.

The greatest part of the film language was developed within the mode of the narrative film, which has always commanded the bulk of the audience, the largest segment of critical concern (including this book, for instance), and the most lavish financing. Most of the historically significant film makers have worked primarily in this mode, although many of the finest have blended the narrative with record (as in neorealism) or with *film pur* (as in the work of Fellini, Bergman, and Antonioni).

All but one of the filmic modes find content analogues in the print media, and may to that extent be described as the "linguistic modes." The narrative film and the novel are similar in content, if not in form. The teaching film differs little in content from the textbook or the lecture, to its undying shame. The magazine advertisement is similar to the television commercial. And the social documentary is often rightly termed a "white paper."

On the modal level, there is more similarity between Bergman and Proust, or, for that matter, between Bergman and the cheapest paperback adventure novel you can imagine, than there is between Bergman and, say, Flaherty.

The mode of *film pur,* be it German expressionism, French avant-garde, or the American underground, is the one mode that is nonlinguistic both in form and content. If the *film pur* must be likened to any of the other arts, let it be likened to painting or sculpture, not to print. It is significant that, in the making of films of this mode, there is almost never a script. One

shot, one pattern of light, one likely subject suggests and gives birth to the next, much in the way a sketch becomes a painting. Images and ideas follow one another in space and time, in terms of aesthetic necessity, rather than in terms of print's linear logic.

In earlier sections of this book, attempts have been made to describe, define, and analyze, as one may do with a linguistic event. It would be very difficult and quite valueless to deal with *film pur* in this way. The mode's enduring value and current high popularity demand that some attention be given it, but the very qualities that make it the most filmic of expressions make it the most difficult to transliterate.

A historical sketch, then. And an attempt to form some general characteristics.

The most casual student of film history cannot fail to notice that great film movements germinate during periods of economic and political chaos. Grierson's documentary movement coincides with England's postwar political and labor strife; the German Street Film flourishes through a period of monetary inflation and moral deflation; the French renaissance of Carné, et al. reaches its poetic heights just as the nation entered the wasp-stung anesthesia of Maginot Mentality and awaited with numbing fatalism its defeat; neorealism emerges from the rubble of war; and the international flowering of the Japanese film as represented by Mizoguchi and Kurosawa followed the most traumatic demolition any modern nation has suffered.

So too with the *film pur*. Although the film form had been available for twenty-five years, it was not taken up seriously for artistic expression until just after the Great War.[2]

German *film pur* produced two important manifestations: expressionism and Hans Richter.

German expressionism, although always a popular field for film scholars, was never really a full-blown film movement.

[2] Incunabular exceptions would be THE STUDENT OF PRAGUE and GOLEM (first version).

Its residual influence was restricted to decor and lighting, largely in the science fiction and horror film. The narrative lines of these films were not expressionistic; rather, they tended to be conventional structures colored by guilt, dreams, and Gothic romanticism. Atypically of *film pur* in general, but typically enough of the Teuton lust for organization, the major studios were involved in the production of the major examples of expressionism, such as THE CABINET OF DR. CALIGARI and NOSFERATU.

The *film pur* movement in Germany was not only shallow, it was brief. Long before Hans Richter began working on his GHOSTS BEFORE BREAKFAST (outside the studios, and not expressionistic), the major studios had abandoned the free art forms for the beefy social drama of the Street Film. Richter's film was the last major *film pur* made on German soil (1927–28). The native revolutionary overtones of the mode were not acceptable to the Nazis who, in fact, confiscated and destroyed the sound version of the film made in collaboration with Schönburg.

The only lingering influence of expressionism is in the decor of the horror film, many of which are beautiful things indeed.

The French atmosphere was more congenial to free filmic expression. The other two schools of presound *film pur*, Dada and surrealism, were essentially Parisian movements.

Political and social revolutions tend to peak in a sine-wave pattern, beginning with the grumblings of a class or group that has evolved to a level of freedom that permits of grumbling, snowballing with power and purpose, peaking in a cacophony of violence and change, dwindling in semisatiation, then submerging in the face of the social pendulum's counterswing. Not so with artistic revolutions, which have precipitous profiles. The movements start near their peak with the bursting forth of a few dominant personalities in possession of new forms, new content, and passionate zeal. Those who follow are either imitators producing dilute clarifications or rarefied ramifications, or

they are mutators who so alter the tenets and thrust of the revolution as to form a new school. The transmutation from Dada to surrealism followed this last course.

Dada began formally (an odd adverb to apply to Dada) with the foundation of the Cabaret Voltaire in Zurich on February 1, 1916, by Hugo Ball and Emmy Hemmings. Dada was antiwar, anti the establishment that had produced and blessed the war, anti the art produced and blessed by that society. Dada was a creative–destructive force. It did not seek to destroy as societies destroy cities to inflict political views on enemies, but rather as societies destroy their garbage for sanitation reasons. The movement was "against," but it was not "away from"; it was a movement "toward." Its inability to define "toward what?" led to its evaporation in the face of the more purposeful surrealism. As Hugo Ball described it in his diary: "Dada was not a school of artists, but an alarm signal against declining values, routine and speculation, a desperate appeal, on behalf of all forms of art, for a creative basis on which to build a new and universal consciousness of art." It is a blemish on the memory of Dada that it was quickly populated by artistic voyeurs and sensationalists who, because they lacked a sense of humor, were comic. Very soon after its transplantation to Paris in 1919, Dada became a platform for exhibitionists and *vox, et praeterea nihil.*

Dada was antiart, antiverse, and antiliterature, but it was not antifilm.[3] Instead, it used the filmic expression as a sympathetic tool for pointing up the underlying hypocrisy of middle-class rituals (ENTR'ACTE; Picabia and Clair, 1924), or for demonstrating the insignificant role of rationale in art (RETOUR A LA RAISON; Ray, 1923), or as a viable plastic for personal expression —one that could harness motion to visual art and deny two-dimensional limitations (ANAEMIC CINEMA; Duchamp, 1924–26),

[3] Indeed, Richter tells us that Apollinaire who, with Jarry, was the literary beacon of Dada, expressed the belief that one day all the arts would be based on film.

or that could create satisfying spectacle through simple forms complexly examined (RHYTHM 21; Richter, 1921).[4]

By 1923–24 Dada had served and outlived its purpose, and it dropped away as a valid platform for artistic persuasion. The mass of hangers-on disappeared, presumably to enter the bourgeois, baby-raising, job-seeking world. A few diehards continued to beat hollow drums (orthodox Dadaists?), but most of the creative men connected to the movement adjusted themselves with grace to Dada's spiritual child: surrealism.

Man Ray was one artist who was incapable of molting facilely from Dada to surrealism. His later films (EMAK BAKIA, 1926; ETOILE DE MER, 1928; and MYSTERES DU CHATEAU DU DE, 1929) remain hermaphroditic amalgams of Dada and surrealism—not clear compounds in solution, but murky mixtures in suspension.

Fernand Léger was also a man outside the mainstream of the movements. He continued his independent personal interest in formal repetition and evocative redundancy (as in BALLET MECHANIQUE, 1924) which has continued as a separate thread in *film pur,* one of the best recent examples being Bruce Conner's REPORT, 1965.

Surrealism produced few films. But among these are the most popular and most often screened of the nonlinguistic mode. They are important also because their dream and sex images were to form the fragile bridge spanning twenty-five years of *film pur* submergence between surrealism and the underground. It is this characteristic reproduction of the dream mode, interlarded with sexual symbol and concern with the sanity of the sensitive man that separates the surrealist film from the Dadaist, which may be described as an extension into the film plastic of interests in pure light, form, and movement.

In certain mechanical ways, the film was an ideal carrier for the expression of the inner realities of dream: The lens could

[4] This film was the progenitor of what Jonas Mekas was later to term "films of light."

distort form, the filmic transition could collapse space and time, and the superimposition could produce simultaneity and ambiguity.

The major pinnacles of surrealist film were THE SEASHELL AND THE CLERGYMAN (Dulac/Artaud, 1928); UN CHIEN ANDALOU (Bunuel/Dali, 1928); and L'AGE D'OR (Bunuel, 1930). Some would also include Ray's ETOILE DE MER (1928), which was surely the most surrealist of his Dada–surrealist mixtures. With the exception of L'AGE D'OR, which was banned in France and has only lately become available through conventional channels in the United States (although pirates of the film were always available), surrealism in film might be termed a one-year movement. The advent of sound, technically too complicated and much too costly for independent film makers, struck the knell, not only for surrealism, but for all *film pur* until the end of World War II.[5]

The dreamlike and symbolic qualities of the surrealist film did not suddenly disappear from the screen in 1930 to await their resuscitation by Maya Deren and Curtis Harrington in the midforties, as some historians of *film pur* imply.[6] These characteristics were continued in much of the work of Luis Bunuel—heroic and resilient survivor of potboiler, banning, The Industry, and near-deification by admirers—any one of which might have ruined a lesser man. And surrealist qualities were absorbed into the products of the major studios, particularly in the films of Jean Cocteau (LE SANG D'UN POETE, 1930; LA BELLE ET LA BETE, 1945; ORPHEE, 1949; and LE TESTAMENT D'ORPHEE, 1959) and, less heavy-handedly, in those of Jean Vigo (L'ATALANTE, 1934 and ZERO DE CONDUITE, 1932–33). Indeed, purposeful distortions of time–space reality, one of the

[5] Both Clair and Bunuel survived the transition to sound. For Clair, sound was a new plastic with which to form messages. For Bunuel, it remained something of a necessary burden.

[6] Deren: MESHES OF THE AFTERNOON (1943) and AT LAND (1944). Harrington: FRAGMENTS OF SEEKING (1946).

characteristics of surrealism that has survived the movement proper, appear in the recent films of Bergman, Antonioni, Fellini, and Resnais. These later films (L'ANNEE DERNIERE A MARIENBAD being the classic example) concern themselves with the displacement of reality in conscious time. They deal with emotional matters. This is a very different thing from displacements of truth, which are perceptual and ethical matters, as in RASHOMON (Kurosawa, 1950).

We have seen how surrealism broke against the rock of studio sound, but how fragments of the movement continued in certain sectors of the main line of fiction film. Then, after fifteen years of silence through the depression and World War II, it emerged in the experimental films of Maya Deren and Curtis Harrington. The most important bridge between surrealism and the underground, however, was through the early films of Stan Brakhage, particularly INTERIM (1952); ANTICIPATION OF THE NIGHT (1955); and FLESH OF MORNING (1956) . But by the time Brakhage started on DOG STAR MAN (1960–64)— which is the magnum opus of the underground—there was no trace of adherence to any artistic school in his work. In fact, the whole concept of "schools" is alien to the underground movement. The differences between Stan Vanderbeek and Ed Emshwiller, between Jonas Mekas and Kenneth Anger, between Jack Smith and Andy Warhol—indeed, the difference between one Vanderbeek film and another—are so great that the film maker constitutes a one-man school followed informally by a handful of university film makers who, in all probability, will wean away soon to do their own things.

This stylistic independence is reflected in the very names of the movements. Expressionism receives its label from the purpose of the artist; "Dada" reflects the nonsense with which its members hoped to deride conventional form; avant-garde was named after an artistic position; surrealism reflects a conscious preference for one level of human consciousness over another. But "underground" is named for a means of distribution.

There has never been an underground manifesto. There is no package of tenets, no single objective, no common guiding principle (except, perhaps, a general antipathy for the filmic establishment, and a common enemy produces firmer bonds than do common interests). For these reasons, the underground is well equipped to accommodate a variety of approaches and products that make it particularly capable of adjusting to diversity and change of taste. The audience for underground films consists of young and youthward-seeking people who accept the experience on its own terms, seldom abusing the film with measurements drawn from established principles of art or film. Throughout the country—particularly around the universities —young people are making their own films, typically within the *film pur* mode. The audience for the underground, therefore, includes active creators and people of liberated film literacy. There are distributors of underground films who make it a practice to accept any product sent to them, allowing others to see the film without first exercising aesthetic or commercial preference and limitation, and this healthy, if chaotic, circumstance does not exist in any other modern art form.

By its nature, the underground film resists both codification and historiography. There is no one label, however elastic or Procrustean, that could be fitted to the icy intellectualism of Warhol and the passionate interaction with images of Brakhage, to the staccato dissections of Mekas and the multimedia medleys of Vanderbeek.[7] And it is pointless to attempt a history of a movement so close in time that its events and personalities suffer from strabismic confusion. The best that could be done at this time would be a diary—notes for a future history.

In the many-threaded fabric of the *film pur,* within the

[7] One of the media used by Stan Vanderbeek is his own personality. His energetic participation is every bit as important an element to one of his showings as are his television distortions, his films, his computer visuals, his slides, his shadow dancers, and whatever else he collects to make image, color, and movement.

several schools and among the many independents, there are a few characteristics that have always separated it from the documentary, the studio fiction film, and the informational and persuasive modes.

First among these is the nonlinguistic character of the films. By and large, the films of Richter, Duchamp, Dali, and Brakhage do not pursue the linear logic of the linguistic film. Images are collected in terms of impression, not expression; they are connected in terms of effect, not reason.

In earlier days the men who made *films purs* were artists who extended their visions into the motion/projection medium (Richter, Picabia, Ray, Duchamp, Léger, Dali). And in the op and pop films of Vanderbeek and Warhol we see a continuation of this transfusion from the graphic arts to film. This is a very different thing from the parallel movement of literary types who transform their words into images, such as the currently popular Swedish and Italian film makers of the theatrical mode.

The *film pur* is the effort of an individual creator speaking one-to-one to the audience members. There is no attempt, as there is in the studio film, to predict and echo the needs and tastes of the mass and impersonal audience. Nor is the speaker a social group or governmental agency with a political, economic, or educational axe to grind, as in the documentary. Because the source is a man, rather than a government or industry, distribution is limited and difficult.

The audience of the *film pur* is usually benevolent and involved. It is not the captive audience of the documentary, nor the improvement-seeking audience of the educational film, nor the indifferent escapist audience of the major studio film, gathered to have the burden of excess time and low inner resource lifted by audiovisual narcotics.

In almost all of its phases, *film pur* has reexamined the mechanics of the cinema. The recording of a story, embellished by "stars" and enlivened by special effects has not been its path. Instead, this mode has asked penetrating questions of the

medium. Aren't things, rather than people, the native subject matter of the film? (Duchamp). Isn't light the principal plastic of photography and, by extension, of cinema? (Richter, Tony Conrad, Peter Kubelka, Paul Sharit). Is the camera really a necessary element in the film? (Norman McLaren). Isn't the dream state beyond the capacity of literature with its spatio-linear restrictions? (Dulac, Bunuel, Maya Deren). Aren't the fragments of an event and the necessary perceptual and emotional evocations they inspire somehow greater than a simple record of the event? (Mekas). Isn't it possible that uncommon attention devoted to a simple event is more evocative than a slight treatment of each of several events? (Warhol).

And these are questions of a higher order than: Will Fabian draw bigger audiences than Burt Lancaster? Will showing starving children embarrass the audience into caring about CARE?

The audience member who attends *film pur* has no guarantee of quality—of controlled accordance with contemporary literary, vaudeville, or social fare. He will see many stupid, many puerile, many self-consciously sensational films. He will see much that is confused and poorly done. He will frequently find himself in the company of aesthetic cowards who dare not voice dislike of what they do not understand. On the other hand, he will sometimes see fresh and sophisticated work untrammeled by Hollywood trivia or television tedium. He will discover that *film pur*, unlike most young movements, is not always humorless (Picabia, Duchamp—particularly the puns in ANAEMIC CINEMA, and the films of George and Mike Kuchar). And he will occasionally see a level of technical skill uncommon in contemporary arts.

It is tempting to end by retracing the linguistic developments that have evolved into the filmic expression. Instead, I prefer to look along the curling edge of the present state of the art

and attempt to predict future thrusts in terms of technology, content, and audience.

Perceptual research around film is very fashionable at this moment, but I cannot believe that it will much harm the main line of film art, and it may give effectiveness, if never quality, to the teaching film.

At this moment, the main-line studio fiction film seems so central to the art that few can envision a time when it will no longer exist. Indeed, to the majority of viewers, the studio fiction film is what they mean when they say "film." And yet there is great likelihood that the theatrical film in the movie-house setting will disappear within the next quarter century. The seeds are already sown. Some major creators are already using other media and other outlets.

A quarter of a century ago, the Thalia, the State, or the Roxy still provided a large part of the total entertainment and information for the masses. Going to the movies was a social affair of low-to-medium status—more than taking a walk, and less than going out for dinner. The screen presented news, sports serials, travelogues, vaudeville shorts, and main features. These main features covered the spectrum from Monogram Westerns with Whip Wilson to imposing historical spectacles. Today, television occupies a large segment of the available visual event, not only in terms of time, but also in terms of genre. Sports, news, travel, serials, and vaudeville turns have transferred almost totally from the screen to the tube. The "B" western (now usually decorated with saccharine family structures and spiced with sophomoric psychological overtones) has also migrated to television. And TV offers the greatest part of the mysteries and situation comedies. Even film's erstwhile role as Saturday afternoon baby-sitter has been taken over and multiplied sevenfold by television.

In some ways, this unburdening of the film form has freed it from the drudgery of mass and mediocre entertainment and

allowed it (indeed, compelled it, economically) to seek upward for possibilities for expansion and aesthetic colonization. Going to the movies is now a social affair of medium-to-high status— still less than going to the ballet or opera, but in the case of the more sophisticated and literary films, the peer of the theater.

There are four qualities that insulate the contemporary feature film from the encroachment of television, temporarily: spectacle, license, distance, and specificity.

Because of budget, flexibility, technical control, economic organization, visual tradition, and—more significant than it would seem—screen size, the film format can offer flows of color, masses of action, panorama, and the exhilaration of broad spectacle presently beyond the range of television. The pre-cerebral delight most of us take in sheer eye excitation will continue to attract viewers to the film theater for some time. But the wall-sized television screen will be generally available in the near future, and, with expanding population (*read:* concentrated consumer market) television sponsors will be able to justify much higher budgets. Admittedly, television lacks the visual tradition of film; it has always operated more like illustrated radio. But that visual tradition resides, not in the film form, but in the film makers and is, therefore, available for transplantation into television if proper attractions are offered.

The cinema has license to reflect certain aspects of life with greater frankness and to present the titillations and purgations of sex and violence with greater freedom than has television, a much easier prey to the wrath of the righteous. This freedom opens entire themes and treatments to film that are closed to television, and we may safely assume that there will always be an audience for these probings into socially tender spots. But there are several factors afield that may one day mitigate television's restrictions. One is the possibility of opening more program alternatives, which will allow the shocked to escape to blander fare (or even, with cable feed, to limit all possible in-

coming messages to exclude undesirable alternatives). Another possibility is a gradual reformation of the tastes and pain thresholds of the audience. This has happened before. It wasn't long ago that cinema was so hampered by sexual restriction that married couples had to be shown sleeping in separate "Hollywood" beds. And, at all events, participants in the current sexual revolution will, in a quarter of a century, be the parents and the lawmakers. So the theatrical film may not forever enjoy exclusive rights to this area of content and treatment.

Distance—from home, essentially—is an advantage of the movie house that will not easily be usurped by television. It is a significant, and underrated, virtue of the fiction film that the audience member must leave his home, his routine, his wearisome surroundings to go to the theater. Here we have spatial escape as well as emotional. "Going to the movies" is one way of "getting out of the house." But expanding population and sequent decrease of individual mobility may take its toll of this spatial escape (although not, one hopes, within twenty-five years). In any case, significant though distance is, it could never alone justify the continuation of the expensive theatrical presentation of film. And if the need for distance, for escape, and for the company of others in pleasure is strong enough, one can propose special large-screen television presentations in teletheaters.

Specificity is the natural advantage of any medium relieved of responsibility for general entertainment. It is the consolation prize in the race for the mass audience. The stage was narrowed to and focused-in on drama once cinema relieved it of vaudeville, revue, amateur nights, and melodrama. In its broadest sense, this specificity allows the film to concentrate its appeal to a given wedge of the audience. We have themeless physical comedies for the family, beach films for teenagers, "adult" films for the vicariously inclined, the *film d'autore* of Bergman, et al. for the intellectual and literary elite.

At first view, it would seem that television could never

produce the multiple channeling necessary to challenge this advantage held by the film. However, within its machinery there already exists the technology for greater specificity, and therefore for greater artistic latitude. The videotape plus the home videotape machine point the way toward a system of distribution that would convert any home into a personal theater. One can foresee the production of very specific messages that would be released through rental libraries and would be played at home at the viewer's convenience. Such a system would allow a filmic expression to amortize its cost over years, rather as a book does, and would make fiscally possible the creation of significant works requiring a limited and appreciative audience. It is possible, well within the twenty-five years we are anticipating here, that filmic "publishing houses" will come into being that will be centers of equipment, financing, and distribution for the personal expression film.

The first reaction to the loss of the movie house might be nostalgia for the carpeted foyers, the overly made-up woman in the box office, the coming attractions, the daydreaming ticket takers, the popcorn, the ushers flirting with mindless candy girls. All this sounds as dreary as most anticipations of the computerized, overpopulated future. But these new technical potentials open exciting possibilities to the film maker. Imagine a production and distribution system that would allow a kind of filmic *A la recherche du temps perdu* wherein the creator could work long and carefully on a magnum opus, releasing it part by part to a refined and appreciative audience that could play and replay favored sections and deal with the work in all moods and all seasons. Exciting potential, and only possible with the specific film and long financial amortizement.

Final prediction. Film itself will disappear.

Well within twenty-five years, film—the celluloid plastic—will be a memory. I share with most film makers a romance with celluloid, with the feel of it in the hand, with the hours spent manipulating it on the editing table. But this nostalgia

does not blind me to the fact that photographic film is an unwieldly and inefficient material for the recording of images and sounds. Film's principal advantages over videotape at this moment are in surface quality and ease of editing, and surely within twenty-five years both of these limitations of videotape will be overcome. One has only to think of the advances television has made technically over the last quarter century, during which time film stock has changed very little.

For the director, the greatest advantage of television tape is the instant replay for criticism. No waiting for dailies, no loss of footage in the maelstrom of the laboratory, no discovering technical problems after the set has been broken down and the actors have been paid off. This advantage, however will not come without cost. The film makers of the future will have to find ways to avoid the drawbacks of speed. They will have to make time to reconsider, to have fresh ideas, to review last night's flashes of insight in the critical cool of today.

So the movie house will disappear, and so will film. What's left? Three rather important things: the film maker, the film language, and the film audience. Regardless of the plastic used to record the message, regardless of the distribution and viewing circumstances, it will be the kind of visual personality we now identify as the film maker—not the audiovisual businessman we know as the television producer—who will create tomorrow's visual expression.

Index of Topics

Index of Names

GLASSBORO STATE COLLEGE